P9-CCL-982

PAINT GOOD & FAST

PAINT GOOD & FAST

By Morris Katz
with Larry Smith

Photographs by
David M. Spindel

Sterling Publishing Co., Inc. New York

Library of Congress Cataloging in Publication Data

Katz, Morris, 1932–
 Paint good & fast.

 Includes index.
 1. Landscape painting—Technique. 2. Still-life
painting—Technique. 3. Picture frames and framing.
4. Painting—Marketing. I. Smith, Larry, 1949–
II. Title. III. Title: Paint good and fast.
ND1342.K37 1985 751.44′436 84-24005
ISBN 0-8069-7982-8 (pbk.)

Copyright © 1985 by Sterling Publishing Co., Inc.
Two Park Avenue, New York, N.Y. 10016
Distributed in Australia by Oak Tree Press Co., Ltd.
P.O. Box K514 Haymarket, Sydney 2000, N.S.W.
Distributed in the United Kingdom by Blandford Press
Link House, West Street, Poole, Dorset BH15 1LL, England
Distributed in Canada by Oak Tree Press Ltd.
% Canadian Manda Group, P.O. Box 920, Station U
Toronto, Ontario, Canada M8Z 5P9
Manufactured in the United States of America
All rights reserved

Dedicated to Leah Katz, my inspiration

ACKNOWLEDGMENTS

The author wishes to thank the following people who were helpful in supplying materials that enabled him to work in "good and fast" fashion, and led to the creation of this book: Mr. Leonard Bocour of Bocour Artist Colors of New York City; Mr. Alan Cornell of Loew-Cornell, Inc. of Teaneck, New Jersey; Mr. Andrew Solomon of S & W Framing Supplies, Inc. of Garden City Park, New York; and Mr. Edward J. Flax of Martin F. Weber Company of Philadelphia, Pa.

Contents

Introduction

You will find two things in this book that you won't find anywhere else.

First, you will learn how to paint masterpieces in just a matter of moments. No one can claim that *Paint Good and Fast* will necessarily supplant the major texts used in the academies. But there are a host of helpful hints here that other artists would never dream of even verbalizing, much less propagating! Because Morris Katz's approach to technique is so unprecedented, someone who has tried to paint, and failed, should pick up this book and try again. Who knows what buried creativities might be jarred loose by prolonged exposure!

Second, you will find Morris Katz himself, and that's mighty important. The time has come for mankind to rediscover the roots of art, or go mad. Now those roots lie in joy and pleasure. They are indelibly democratic and depend for continued survival on a humor sufficiently robust to sustain them. *Paint Good and Fast* isn't simply a course in how to paint; it's a rollicking good lesson in how to *be* an artist, from the dreams you dream to the jokes you tell.

Few artists are teachers; few teachers, artists. Yet what a happy conjunction we have here, what an antidote to sterile intellectualism and elitist self-torment. Morris Katz . . . read him and join the giants!

—Larry Smith

Chapter 1

Be Brave, Be Fast

Envision if you will a group of firemen sitting around Italy in the fifteenth century during the Renaissance. They're relaxing in the engine house, playing cards, smoking cigars and waiting for the next alarm to go off.

"That Michelangelo's a real blowhard," says Giuseppe to Antonio.

"You ain't kidding," says Antonio. "For twenty years he's been a fireman and for twenty years he's been bragging about what a great artist he'd be if he only had the time."

"He couldn't paint the side of my barn, if you ask me," chimes in Pasquale.

Suddenly Michelangelo walks in. Now he's no dummy, this Michelangelo, and he knows that they've been talking about him. He can even guess what they've been saying. "If I had the time," he protests, "I'd paint the most beautiful pictures in the world. I'd paint you a whole cathedral!"

The others fall over laughing while Michelangelo goes over to the corner and sulks by himself, his head in his hands. "Oh," he says, "if only Morris Katz were here to teach me how to do it fast!"

It's no joke! Can you imagine how many Michelangelos and Leonardos labored in obscurity as shoemakers and tobacconists and blacksmiths, never knowing that, with the proper instruction and encouragement, they too could have risen to the heights of their more illustrious contemporaries? But thank God we live today in a better world. Today we have mass communication, and you don't need to be born in the right place at the right time to study as an artist. Just knock and the doors will open.

This book is one of those doors. In it I hope to teach you

the rudiments of painting. I can't make all of you Michelangelos; that's up to you. But I can get you started and, at the very least, you'll wind up delighted with some lovely paintings of your own and a few hours of fun achieving them. You don't need to bring anything with you. You don't need an apprentice's card from a trade union. You don't even need to offer me a lifetime of devotion.

All you need to bring is a little courage. Don't let anyone scare you. Don't let anyone tell you you can't do it and you shouldn't try. This book is for busy people who want to create masterpieces by themselves in their spare time. There's no reason why the firemen of today can't paint a Sistine Chapel or two while sliding down the poles.

The biggest nonsense in the world is that a masterpiece has to be painted slowly and painstakingly. No artist wants to admit that you can do a good picture in just a few minutes. But look at the facts! Look at art history!

John Singer Sargent was the greatest society artist of his time. Each year he's re-evaluated by the critics and each year his reputation increases. And do you know what? During much of his career he was painting two, sometimes three, portraits a day.

Monet is an even better example. Every morning he'd set up his easel out by those bright haystacks and before the sun set he had painted at least one picture, sometimes more.

And what about this Picasso fellow? He was a one-man factory and he drew half those sketches which now sell for thousands of dollars in a matter of moments. I don't begrudge Pablo, may he rest in peace, so why should his fancy

admirers begrudge you or me? There's plenty of soup in the old art pot for all of us.

The idea that you can't make a good painting in a short amount of time has a lot to do with the old notion that you can't be an artist without suffering. If you're enjoying yourself, the public is told, you can't possibly be painting anything worthwhile! And, likewise, if you don't sweat and strain at your work, it must not have great value.

I wonder if anyone *really* believes this. Again, look at the record. How much suffering do you think Picasso endured doodling lucrative little stick figures while his mistresses were attending to his every need? True, the great self-portraits of Rembrandt bespeak unutterable agony, but then think of all the great art that just radiates tranquillity and joy. Take Dufy, Chagall; there are any number of fine artists who can personally attest to the fact that you can paint marvellous pictures while also having yourself a rip-snorting good time.

Closely related is the issue of money. If you're a long-suffering artist of genius, you're not supposed to make any. Yet if you paint fast, you can be sure you *will* make money because you'll be prolific. I have done over 130,000 paintings in my lifetime, and I have earned around $5 million from my art. Unfortunately, speed is frequently equated with greed. But the fact is, whatever your work, the ability to do it fast is an asset, an important quality. If you can turn out enough paintings in one hour to please everyone in the room—rather than one painting for one rich person who manages to outbid everyone else—then why shouldn't you be able to earn much more? Sometimes I think the high-

brows in the art world live in horror of making too many people happy. And I would also like to point out that I have never knowingly sacrificed quality for speed. If I thought I could produce a better still life in four days than I could in four minutes, I'd gladly expend the time. But I *can* do it fast just as well, so why shouldn't I?

It will be a pleasure for me to devote some pages in this book to advising you how to sell what you paint. If you're as good as I am, there's no reason why I shouldn't have a little competition. There are hotels and restaurants from Maine to Florida to Seattle just screaming for nice florals—and what about those good folks in Nebraska who have never seen the Atlantic or the Pacific? Don't you think they're willing to pay a fair price for a decent seascape?

I'm going to concentrate on two types of paintings. First, we'll do landscapes and then we'll tackle a still life. I will also give some attention to black-and-white art since that brings with it somewhat different problems in conception and execution. As you will see, all three modes can be learned in a few steps each. I will also tell you what you need to know about art supplies, for more than a few neophytes have been needlessly scared away by the seemingly formidable gamut of options open to the consumer.

What we are doing here is *the* truly "modern" art, and I hope you will welcome this opportunity to be a part of the movement. No, modern art is not overly intellectual abstraction, nor does it stand for morbid canvases showing mass murder and decadence. Modern art is really just like modern anything else: fast, democratic and to-the-point. I think that sooner or later what we're doing here will be

viewed as prophetic. Life isn't going to get any slower. In fact, it's just going to get faster and faster. The fine arts must keep pace, just like the practical arts.

And not just in painting, either. Soon music and literature will join the ranks, and people like Morris Katz will be publishing books on how to sing good and fast or write good and fast. Why should *War and Peace* be a thousand pages when a good author can solve the same problems for the same characters in fifty or sixty pages?

I have one other, semisecret joy in doing this book. I know that so many of the young painters who pal around at cocktail parties with the artsy crowd are just about to break under the weight of their own pretensions. I know that, deep down inside, they despise the jargon, but they're afraid to admit it, or to paint as I do, because they're afraid of not being taken seriously. Not everyone with talent is brave. And who can blame them? Art critics have great power and can destroy an aspiring painter. That's why it's so important to become independent of these people and learn how to survive without their approval.

Well, I think a lot of those young artists are going to read this book and rejoice—even if they must do so clandestinely—because they know how corrupt the art world is. They know that the ruthless phoney-baloneys who control their careers deserve this slap in the face.

To tell you the truth, rapid painting is already spreading like wildfire, well beyond the narrow confines of the art world. I have just heard from a prominent U.S. senator who will remain nameless, and he tells me that politicians now waste billions of tax dollars by spending a full four years

running for President. Accordingly, he has decided to write his own book called *Get Elected Fast*.

But that's his job. Our job here is art, as good as possible and as fast as possible. You should, however, understand—and we will certainly have occasion to repeat this—that art never really stands alone. It is inextricably mixed up with the flesh and blood of the men and women who make it. No matter where I paint—and I do most of my painting in front of audiences—people are always interrupting to ask me where I'm from, where I studied, and whether I'm married. It's not just idle curiosity. They see the painting and they see the man. The urge to understand one via the other is irresistible.

So before we dive into the actual techniques of what I now call Instant Art, I think it will be instructive to tell you a little more about myself, the man who invented it.

Chapter 2

My Life and Fast Times

I was born in a small village in rural Poland. Eastern Europe is, first of all, a very colorful place. Artists like Chagall are no accident. I don't know of any area of Europe where the peasants dress as interestingly as in Poland. And even the quickness of their step, and the heartiness with which these locals are animated as they go about their daily chores, seems more pronounced than in France or Italy or Scandinavia.

Just as important was the natural beauty that surrounded me, though obviously an urban atmosphere can be just as conducive to art. Had I been born in the *shtetl* of Warsaw no doubt my youth would have been treated to a feast of color and movement that might also have made my choice of a profession inevitable. Indeed, the ghettos have long played a major role in world art if only because Rembrandt chose to live and work in one. Just beyond the ghettos were great cities like Paris and New York. The sheer volume of paintings depicting the Seine or the Brooklyn Bridge demonstrates just how inspiring such places have been for artists. Of course a great many of us have chosen to live in cities, not in the country. I, for one, have studios in New York and Jerusalem. You don't see me still living on a farm milking cows. That would be udderly ridiculous.

Yet the power of nature in forming my artistic outlook is something I cannot overestimate. As a child I internalized and absorbed the look of the wild and primitive countryside. Most city people must spend years cultivating their perceptions of gnarled roots and branches, the twisting and turning of the bark of ancient trees. For me those phenomena became as much a part of my consciousness as the Polish language.

Out there, among the hamlets of Eastern Europe, you learn to read the sky for weather. There's no staff meteorologist to tell you how to dress. Every sky has its own message, its own unique way of speaking. Maybe all farmers are just a step or two away from being artists. If they *read* nature, if they delve into it in order to pluck out the knowledge they want, they've taken the first enormously significant step on the way to true art. The most important lesson I can teach you now—before you ever pick up a piece of canvas or a palette full of color—is to remember the simple farmer and how intently he must study the sky and earth around him. The next time you look at the clouds, do so as if your crops and your very livelihood depended on your capturing their configuration in your mind's eye.

Basically, then, when we talk about nature, we're talking about two processes that are central to artistic development. First is the internalizing of the wildness and beauty around us until the very forces that push a flower up through the soil become a part of our actual human bloodstream. And second is the ability to observe nature, to decipher its daily round of messages. Once you do that you're on your way to an understanding of shape, movement, color, light and texture that no instructor can give you. What growing up in a rural environment did for me was to make me both primitive and sophisticated at the same time: primitive, because there were thunderstorms in my bloodstream, and sophisticated, because I could comprehend the enigmas unfurling all around me. To this day I veer in my work and in my life from simplicity to convolution—and sometimes within the space of a single canvas.

Perhaps that is why all true artists are, in some way or other, primitives. They need to be around ceaselessly vital forces. A city will suffice, for the squeal of subways, the obscene noises of the streets. The panoramas of life and death are, in their way, just as elemental as the encroachment of winter upon a barren landscape. Now what happens when the artist, in order to be an artist, invites those primitive forces into his soul? He becomes a raging dynamo of a creature, as driven as the wind. You think I'm weird? You should have known Jackson Pollack!

My upbringing in the wilds of rural Poland is a major reason why, despite what my detractors may say, I can never be cynical about my art. How can I be cynical about my own bloodstream? The trees I draw are as much a part of me as my fingers.

The final point I would make about the effect of nature on my art is that it played a major role even when I was doing portraits of American presidents. I suppose that a familiarity with nature has often stood portrait painters in good stead. Remember, the human face is not independent of nature. Quite the contrary! A face is almost morbidly sensitive to the world around it and the ravages of a long and spiritually gruelling wintertime. A man or a woman, no less than a tree, is best understood as a product of the same forces that harden the bark of an oak or deepen the green of an elm.

What then should you as a neophyte artist do if the only tree you've ever seen happens to grow in Brooklyn? I would first of all repeat what I've said about cities, that they can give you the same vibrancy and power that painters like

Winslow Homer have found in the tumults of the sea. But I would also give you some simple practical hints.

Take a ride out in the country alone. The company of someone like yourself will only keep you locked up in your own cosmopolitanism—and don't take anything to read. Once out there, don't try to study anything, at least not at first. Be passive, just like a baby. Don't even remark to yourself on how pretty everything is. Just find some place to relax and let it all wash over you.

Then, in the course of time, as you take a few more casual jaunts out into the wild, you can begin to hone in on what you see. But there's no need to overdo it. You're an artist, not a botanist or a geologist. Loving what you see and enjoying the experience are your top priorities. If you happen to live in the Northeast, I would particularly recommend the Catskills for this experience. That way, after you're done letting nature wash all over you, you can go have a nice meal at the Concord. (Tell them that Morris Katz sent you.)

Nature isn't the only force that has shaped my experience. There have been at least two other factors that have urged me along on the road to art: first, the fantasies that swirled in my soul, and second, the many people whose kindnesses have graced my life.

Fantasy, first of all, is a prerequisite to art. All people have fantasies; the only question is, to what extent can we as adults continue to indulge in them? In childhood, I believe, everyone's life is dominated by make-believe. Often they're dreams of power or dreams of adventure. It's hard to say which fantasies are really most translatable into art. I do know, however, that an adult who has unconsciously re-

pressed this part of himself will have a lot more trouble becoming an artist.

The one fantasy that has always been central to my life is the fantasy of flying. As a child I imagined myself hovering above the fields and forests of Poland. I could climb as high as I willed, until the meadows were mere specks of green, and then I'd dive-bomb down until the colors of the land were massive seas of brown or red rushing up towards my eyes. Sometimes I'd just cruise along, drinking up the air as I flew and enjoying the varieties of terrain or the cool breezes as I changed my altitude.

You can see already how fantasy might lead to art. If nothing else, these imaginary thrills of flight sensitized me to all the colors of the landscape. I couldn't really live this fantasy to the fullest unless I concentrated hard on the streaks of green across the flat meadows or the treetops; and as I intensified my delight in this fantasy, I would naturally have to guess how all those colors might change with each new positioning of the sun or slant of the light.

To this day, flight is my central fantasy. In fact, it has become more than a fantasy: It is a constantly recurring motif in my dreams. Now, however, it is usually New York or Jerusalem I'm flying over. I often paint the Holy City; its rising parapets and minarets, not to mention the exquisite sanctity of the place, are attractive to many of my customers, and a stint at a hotel in the Catskills seldom ends without the guests requesting a Jerusalem or two. In my dreams I soar over the Wailing Wall and gaze down at the narrow streets and milling crowds.

I don't paint New York very often anymore, but in my

fantasies I am frequently sailing above its skyline. You can't live in New York without its physical assets etching themselves into your skull. New York is indeed a city of fantasies. The last time I soared above it, I saw King Kong nuzzling Fay Wray atop the Empire State Building. Gracefully I extricated the damsel and brought her safely home to Brooklyn Heights. 'Twasn't the airplane, 'twas Morris Katz killed the beast! (I can paint you a rendition of this scene for less than $75.)

I realize that this flying fantasy is simultaneously a kind of death fantasy. People who have "died" on hospital beds and then been revived invariably report that they felt as if they had been hovering above the room, just as I hover in my fantasy. This is a very important and profound part of art, and one needs great intellectual power to totally grasp it. I do know, however, that death and art are very closely allied. The creative process itself is a constant cycle of dying and being reborn. Most great artists are very intimate with death and think about it constantly. It stands to reason that if artists are necessarily close to nature, they will be close to death as well, since the spectre of death is a constant in nature.

Fantasy and painting are also allied in other, more logistical ways. If you have driven your childhood dreams completely out of your head, how imaginative can you possibly be while you are painting? You will have desensitized yourself too much and what you end up drawing will most likely be just a hollow exercise in technique. Art, of course, is discipline and hard work, but it is also a kind of play. While I work, it is as if I am professionally fantasizing; the very

movement of my knife across the canvas is like the flight of my body over the fields of Eastern Europe.

The next advice I would give you, therefore, is to cultivate fantasy as much as you can. It's not a difficult chore. It really only requires a simple act of will to get a good fantasy going. Just be sure to look for those things in your life that can trigger a dream. If you happen to hear Beethoven's Third Symphony, remember to imagine that you yourself are Napoleon. If you chance upon a big tree, imagine yourself a child climbing it. If you go to the zoo, pretend you're in Africa. If you see a particularly attractive member of the opposite sex—oh, modesty forbids I go on!

The final aspect of my life that I would like to discuss is a big one, for, like everyone else in the world, my destiny, both in childhood and maturity, has been moulded by the people who have known me. My mother was a particularly sensitive person. Leah Katz viewed art as one of the highest goals to which a human being can strive. I think that had I decided to remain in our village, a cobbler or a farmer, she would have accepted it with characteristic grace. But I always knew that she cherished fonder hopes for me. Had she been a grasping, obnoxious woman I might have grown to hate all creative expression. I would have changed my name to Trotsky and become a Cossack. But no; thanks to her, I have always associated art with everything in life that is nourishing, forgiving and utterly lovely.

My first real contact with the art world came after the War, and it was with people who actually viewed painting as a profession rather than an eccentricity. World War II, of course, changed the history of art because many great artis-

tic thinkers of Europe had to flee to the Americas. In my case, a crucial experience preceded my immigration. I was in a Displaced Persons camp in Germany, which was operated under the aegis of the American occupation forces. It was a lovely place, situated just by a river. The Americans had set up classes at the camp in art, English, business, etc., and would even give a little money to anyone who showed signs of application and diligence. Truly nice folks, those Yankees! I studied art there with a saintly man named Furtzeig, who was from the Warsaw Academy. Our initial assignment was to draw a chair upside down. Furtzeig studied my effort for some moments and then pronounced judgment.

"Katz, shine shoes. Don't paint."

But I persevered. I did a castle next and Furtzeig was amazed. In fact, he asked to keep it! That was just the encouragement I needed to bolster my resolve. Twenty years later I ran into another fellow I had known at the camp. I inquired after Furtzeig, who I thought might be living in Israel, because I wanted to visit him. I was told that the old man had just passed away, no more than a month or two before. I was crestfallen.

The next year I studied with Doctor Hans Fackler from the Munich Academy of Art. This was in a small German town called Guinsberg, where my mother had gone. Those were lean years, of course, and even as venerable a figure as Dr. Fackler was willing to take in students for a pittance. I will aways remember my mother recompensing the old man with a handful of chocolates. It is an image that often comes to me when I think of Europe in those days.

I stayed with Fackler for nearly three years as his apprentice. It was a great adventure for me; in fact, I still own one of the first watercolors I did for him. Paints were in short supply, as you can imagine, so I learned how to make my own oils. I completed around seven sizable oil paintings and sold the lot for $5 in American money, a veritable bonanza. These are currently owned by people in New Jersey, Brooklyn and Australia.

In 1949 I came to America on the good ship *General Muir*. We went to Newark, where my mother had uncles, Charles and Max Rothenberg, and an aunt. I found a job at a doll-manufacturing concern where I lifted and loaded and unloaded until my arms and back were like sides of beef. I was some Gorgeous George in those days! In the meantime, I was studying art again at Washington Irving High School in New York where, to this day, a human being can learn just about anything he wants.

I was also studying art with a man named William Schnelley. It was with him I learned anatomy by sketching nudes. In those days fifty or sixty students would pile into a class and the model would get about 25¢ from each one. And I started selling. A man named Philip Globus, who had just sold his mail-order stamp business, fulfilled an old longing by opening up an artists' showroom. I would supply Globus with a number of paintings each week, and he'd pay me $15.

Finally, in the early 1950s, I made it to the Art Students' League on 57th Street in New York, which is one of the famous institutions in the history of American art. Their student and faculty roll reads like a *Who's Who*. In fact, I

can't think of an important contemporary American painter who hasn't at one time or another taken some classes there. The salient virtue of the League was the tremendous freedom it accorded each individual. There is no ideology at the League. You are able to pursue whatever stream befits your bark. After all, how doctrinaire can a school be that will produce both Mark Rothko and Morris Katz? If you wanted to investigate Dadaism, cubism, or superintellectual notions that had come over from Europe and the Bauhaus, they were there as well.

I had other fish to fry. The most important teacher for me at the League was Frank J. Reilly. He taught something very different from abstract expressionism. What he taught was that if you know your ABC's, and can command the rudiments of technique, you will never starve. Frank Reilly spoke my language. From him I heard that money in the bank is better than no money in the bank, and that I should never feel inferior to anyone for saying so.

There were other fine teachers there for me as well. There were Ivan Olinsky, John Carroll, Sidney Dickinson, Robert Brackman. It's a pity that such names are not better known, because not much of their own work hangs in museums. What they fed into the mainstream of American art merely by being at the League and making themselves accessible to their students is incalculable. I myself was attending three classes a day—morning, afternoon and evening—and finally supporting myself solely by painting. I wasn't getting rich on $30 a week, but I had high hopes.

And then, in 1956, came the millennial moment. Some four or five million years after the invention of the wheel,

yet a mere half century after the discovery of flight, Morris Katz invented Instant Art. Here's how it happened.

That summer we were given an assignment from the League to break down the color chart. As you know, the visible spectrum stretches from black to white, and in between are all the colors known to man. It is very important for artists to learn to do color charts because it trains the eye as well as the hand. You get nimbler and nimbler until the various gradations of color become second nature to you.

Through the hot weeks of July I labored at one chart after another. No doubt I had adequately filled the assignment, but some instinct made me push on. I was like a boxer who shadow-punches in his sleep well after his trainer is satisfied that he's sparred enough. By August I was doing color charts nineteen hours a day! My head began to stretch. My fingers began to move automatically. Before I knew it I was painting rainbows in a matter of thirty seconds.

Then it occurred to me that, with this intensified facility, I could do a whole painting in a matter of moments.

It was like being a writer whose knowledge of the dictionary becomes so facile, so familiar that he can manipulate any combination of words almost at random. Yet this would be even better, for pure verbal facility is of no use to a writer who has nothing to say. A painter, on the other hand, can always do a landscape or a still life. Nature is always there in front of him. He doesn't need to be constantly manufacturing new situations and angles in order to work.

I could barely sleep that night. I knew if I could produce volume, I'd sell cheap and undercut the whole European

market. The next day I tried it out and did a still life in less than an hour. I ran with my idea to Frank Reilly and he was mightily impressed.

"Morris, you've crossed the threshold," said Reilly. "Never again will you be satisfied to wake up in the morning like some phoney genius of a painter and say, 'Oh dear, I'm not inspired today!' Instead you'll sit down in front of your easel and go to work in the morning like everybody else in the world."

I was a *professional* now, with Frank J. Reilly's personal seal of approval. But still I hesitated. Was it really the path my talent and training had led me to? Or might it not be better to hold out, to practise a more "official" art and hopefully earn the approbation of the intellectual community? That was when my brother Charlie stepped in.

No one, not even Reilly, could have played a more important role at this point. Charlie knew me as well as anyone did. He knew my background and could see, even more clearly than I, how all the years of struggle had led me to this one point.

"You found something," he said, meaning Instant Art. "Do you think you found it by accident? Now *use* it. Use it to make money. And use it to make people happy."

I should add at this point that the technique of Instant Art, which is designed mostly for pastorals or cityscapes, did not replace my career as a portrait artist, at least not until many years later. On the contrary, I began to study portraiture in even greater earnest.

I worked with a man named George W. Gage, whom I had met at the Metropolitan Museum. We liked the same sorts

of paintings, and I was happy to cultivate our affinity. I think it is particularly significant that that day at the museum we both gravitated towards the American primitives: those coarse, flat and yet powerfully expressive works done by simple men and women whose names today are all but lost in time. It's odd how the same critics and curators who are enraged by my work will hang those older primitives on the wall just beside their oh-so-respectable Copleys and Stuarts. I guess they must figure that if you entertained people with your art in 1784 you created a "significant document," but if you do it in 1984 you're just a prostitute.

I began doing fast miniature portraits. European men with pipes were hot items at $75 apiece, and I was able to finish each in two weeks. In the meantime, I was doing super-realistic landscapes in black and white and then going over them with a brush loaded up with color. Finally, I discovered how to utilize a palette knife along with bunched-up toilet paper to add depth and subtlety. This would simplify the process of Instant Art even further. As we shall see, the palette knife is the principal tool for the Instant Artist. I should therefore tell you a bit more about how I came to use it.

It was simple enough, really. I had been mixing the colors for my color charts with a palette knife and then transferring them to the brush. It suddenly dawned on me that that final step was unnecessary, especially for the sorts of paintings I was hoping to market. Besides, I was wasting literally hours cleaning brushes. An artist sometimes spends as much time on logistics—setting up and cleaning up—as he does working. I was hell-bent-for-leather to lop off as much

time per project as possible. The fewer brushes I had to wash, the quicker I could get on to the next painting, and the quicker I could finish it and sell it.

So I would just apply the palette knife to the canvas, using either its flat side or its edge or tip, depending on my need. I think this is a particularly important point to make to any reader who is thinking of taking up art for the first time. I wish I had a dollar for every talented beginner who has decided not to paint because of the time and expense necessary to keep tools and supplies continually refurbished and in tip-top shape, or because of the difficulty in finding studio space. But the fact is, there are always ways around these obstacles. Not many artists use *only* a palette knife, for example, but I eliminated hours of labor by taking this one little step.

The use of the palette knife should establish once and for all how I was able to add directly to the tradition of the Old Masters. The Old Masters emphasize four dimensions in art. One is proportion. My paintings had it. Second is color. My paintings had it. Third is light and shade. My paintings had it. Fourth is perspective. My paintings had it. But I was not content to simply emulate their great example. I wanted to be an innovator, so to their four dimensions I added a fifth: money. And my paintings made it.

I would not return in earnest to the brush until 1963, and then only temporarily. After the assassination of President Kennedy I decided to paint his portrait more realistically than the knife would allow. When that work was done I decided to do all the American presidents in just the same way, using the brush to achieve a more photographic veri-

similitude. This presidential series was for me an important achievement, but it would hardly deflect me from the Instant Art that was my true métier.

Indeed, three years earlier, I had hooked up with the J.A. Olson Company of Winona, Mississippi, the largest picture-frame distributor in the South. Once upon a time, in the Renaissance, artists were patronized by the nobility. They were given a nice little palace to live in and commissions to paint the families of their benefactors. Nowadays, it is the American corporation which does most of the patronizing. In fact, many top executives will subsidize the most god-awful abstract paintings, which they themselves can't stand, because somebody told them they ought to. A critic will often convince a corporation to invest in some nonsensical painter because his canvases "maintain the reductionistic impulse vis-à-vis painterly non-depiction" or "invert the spatial disproportion of organic de-verticalization."

Actually the critic owns three or four crummy paintings by the young fellow, and if the corporation starts investing in this new guy, his reputation will grow, and the critic's own holdings will rise in resale value. And this is probably the same critic who calls Morris Katz a "prostitute."

In any case, just as Michelangelo had his duke and Leonardo had his count, I had J.A. Olson. This company gave me the opportunity to paint as many pictures as I possibly could, and no matter how many I painted, they guaranteed that they would buy them all. It had really been my own enterprise that had gotten me this plum. For some years I had been selling to dealers who would scratch my name off the works and resell them to Olson. So I did what

many successful people have done, and cut out the middleman.

Olson would pay me around $20 a painting, but I was doing high volume, and they were making a fortune by avoiding dealer mark-ups. In three years I did around 6,000 pieces for them which sold throughout the South and Southwest. Every few months they would bring me down to Winona and I would turn out a batch of paintings. Don't forget, it was cheaper, easier and safer to transport *me* than my paintings.

It was also Olson that gave me my first taste of personal performance. The company learned that if they brought me to annual trade shows in places like Amarillo or Baton Rouge and let me paint in person for the buyers who attended, I would arouse enormous curiosity. This was still the early 1960s and the American South had not yet attained its present degree of cosmopolitanism. A Polish Jew doing a landscape in seven or eight minutes while yapping out antique jokes with a thick accent (which I have kept) was not something they were used to seeing every day. I got super-publicity for everyone.

Soon Olson was selling its frames in great quantity by leasing my personal appearance to stores like Goldsmith's in Memphis. I was making invaluable contacts and continuing to hone my craft. In fact, from the first day I invented Instant Art in 1956 to the present, I have cut down my time per painting from forty minutes to four minutes. And just as important, my experience with Olson and their retailers had taught me how to entertain an audience. The same

things that delight nice people in Little Rock delight them at the Nevele Hotel in the Catskills.

And now I must give the most important advice I can possibly give to an artist. If you make a lot of money selling art, don't invest in commodity futures!!! I did, and in 1969 I was wiped out, lock, stock and barrel, by a silver deflation. If you want to play around with stocks, OK. A municipal or two can't kill you. Even options can be fun if you don't mind a little sweat. For landscape painters I particularly recommend mutual funds in government securities. These are particularly good for landscapists who seek security and peacefulness. A Ginnie Mae where the principal is safeguarded by the government is like a quiet scene by a quiet river.

I was about to starve! So I did what anyone in my position would do. I put on a beret and went to the Catskills. I was starting all over again, but at least I knew how. I simply started to paint for people wherever I could. Crowds would gather and, in a few weeks, the hotels realized the value of a showman like me. My act was perfect for rainy mornings. If it's coming down buckets and your guests are disgruntled, what do you do? You can't ask Buddy Hackett to tell jokes and Sergio Franchi doesn't sing before noon. But Morris Katz can come to your rescue anytime.

Now of course I'm a big star. I've been on the Mike Douglas Show, Joe Franklin's, Alan Thicke's, Rich Little's, and others. I even have my own cable TV show Thursday nights on Channels D and C in New York. Women chase me down the street (sometimes brandishing formidable weapons, but

not always). And I owe it all to the hotels of the Catskills. It's my grass roots and will remain so until the day I die.

I cherish my TV appearances because they give me an opportunity to do for a large audience the very same thing I do for the more intimate crowds at the hotels. I'm not just a showman and I'm not just an artist. I also want to be a teacher. If everyone who saw me paint could go off and do the same, I'd feel very accomplished. So, towards that end, I have simplified my creative techniques as much as possible by breaking them down into four general steps. The next few chapters will discuss these steps and how they apply to landscapes, still lifes and miscellaneous black-and-whites. Let's start with the landscape.

Chapter 3

Vibrant Lakes and Shiny Skies

There are of course innumerable kinds of landscapes. Indeed, one of the joys in painting them is the freedom to choose *this* particular topography or *that* genus of shrub, *this* sort of weather or *that* thickness of cloud. Sometimes the mere inclusion of a faintly drawn person or wisp of smoke from an unseen chimney can change the whole character of your work. As your proficiency in landscapes increases, so too will your pleasure in their immense variety.

Of course this variety also presents something of a problem, namely, which sort of a landscape should I choose for this instruction? I decided, first of all, that trees are indispensable, though many of my customers do enjoy seascapes as well. Yet seascapes would involve additional complications that would stretch the scope of this book. I decided that a good compromise would be to do trees along a river bank. That way we can practise all the rudiments of a good landscape: grass, trees, sky and water.

As I have said, your basic tools are a palette knife and toilet paper. Now, you're going to be giving the knife quite a workout. Just about every color on your palette will be applied, and both the side and top of the knife are important. The toilet paper will add remarkable form and substance. But it should also be used to clean your knife as you paint, so keep an extra roll or two available. Soon the motion by which your one hand, holding the paper, cleans the knife in your other—almost after every daub—will be automatic.

I realize how eccentric the use of toilet paper might seem. As we shall see, it is a very practical material and using it is not merely a scatological publicity stunt. In my autobiographical remarks I chose to emphasize how in my

search to perfect the techniques of Instant Art I chanced upon the palette knife. Yet anyone who has seen me work will likewise testify to what miracles I can do with a full roll of toilet paper and a good head of steam.

Step 1

The first step is background. Using your palette knife, coat the canvas with a fairly uniform layer of paint. Since this is a landscape you must apply color to this abstract layer, for it will eventually have to represent sky and water. So get in some healthy blues and greens, but also be creative and have fun. Don't be afraid to include some brown, while lighter colors like yellow can also be used. Always remember, though, that the green and blue ought to be prominent.

An easy-flowing wrist motion accomplishes this background. Naturally, you will be using the flat side of the knife. When you start your first painting, spend some extra time applying the basic colors. While it is never a good idea to thicken a canvas with disgusting mounds of superfluous paint, for your first time, it can't really hurt to get the feel of the knife as much as possible.

Already, in this rather uncomplicated first step, we have need of the toilet paper. As you know, no background is really flat. The sky is alive with so many shades of color that some are projecting towards us while others seem shy and hang back. Before you ever start painting you must memorize a basic principle: light creates depth and form. A sky crayoned by a child doesn't really look like a sky. It is too uniform. Nothing is acting upon it, no sun is forcing one

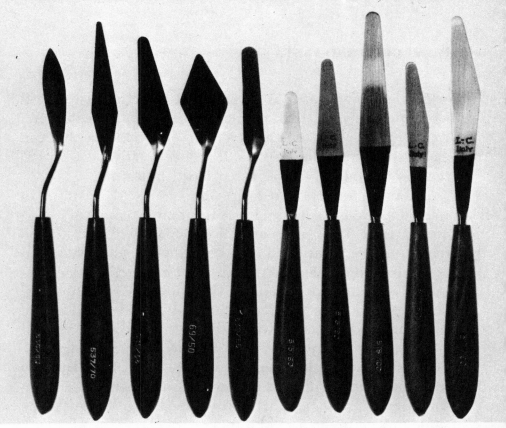

536/50 537/70 538/65 69/50 539/55 515/60 515/80 515/100 517/80 517/100

PALETTE KNIVES—An assortment is available in art supply shops. My favorite has a long point—No. 537/70. (Courtesy Loew-Cornell, Inc.)

patch to appear distant and hazy, while causing other spots to look as if they're bulging down on us.

To create depth in your background use the tips of a piece of toilet paper and gently dab the surface. Small dots create what is called a pointillist effect. Already you will note how those dots lend dynamism to the surface, as if pieces of color are dancing in various directions.

Though toilet paper is a very light material, it can still slop up a canvas if used carelessly. I therefore recommend that you learn how to hold a piece of toilet paper so that you can easily manipulate its tips. It is never really necessary to tear off more than two or three sheets at a time.

To further understand what we have just done, think of the foundation of a house. It is a beginning, a mass of inchoate material. You can't really know what it will be until you happen to see it situated on a construction lot or between two other completed houses. *It is an abstraction.* Abstraction always precedes realism. The windows, the lintel, the chimney will later identify it. So too with skies and rivers: They proceed out of a swirl of anonymous color. The next time you see an abstract painting by a true master like Pollack or Kandinsky, don't dismiss it out of hand. Think of it as matter in the process of becoming a recognizable something, and remember that you yourself have followed the same procedure as part of a more conventional endeavor.

Step 2

It is in Step 2 that form begins to emerge out of the lovely chaos. And so easily too! You don't need to build a Hoover Dam to harness the raging waves of color. All you need is one broad horizontal band across the center of the painting. True, a stranger looking at your work still won't know what it is, but you will. You'll know that this horizontal band is quite simply the dividing line between land and water, while above it is the sky. No, it's not yet a picture, but it now has the essential outline.

Using the palette knife, simply drag some paint from one

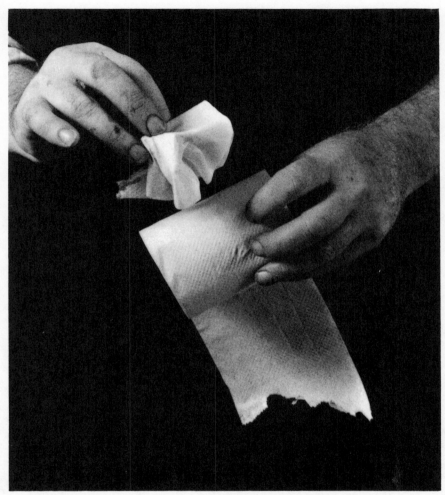

From your roll of toilet paper, tear a length of 8 sheets and, folding it back and forth on the perforated lines, make a wad the size of a single sheet. Fold it into quarters parallel to the perforated lines and then in half in the opposite direction. This will give you a wad with the edges of the paper protruding.

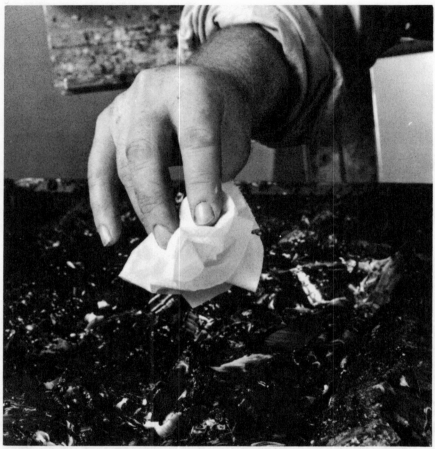

Holding the wad of toilet paper as shown in the picture, dip it heavily into the paint on your palette so that the edges catch the paint.

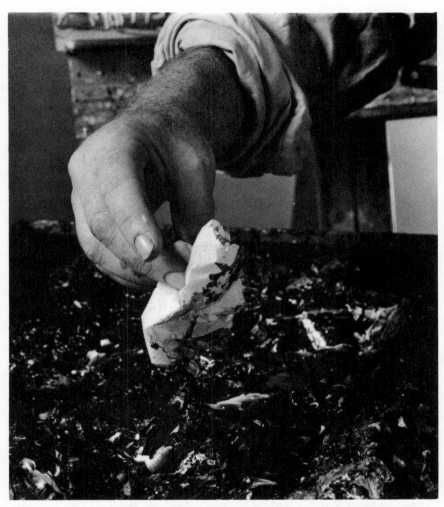

The paint has now adhered to the edges of the toilet paper. Dip it once again to get more paint.

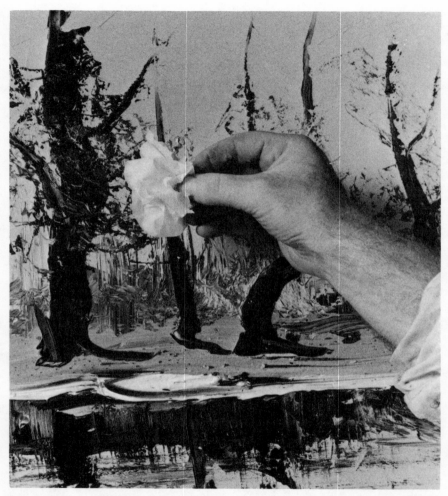

Press the wad lightly with the painted edges against the treetop to create the effect of leaves. If the impression is not strong enough, then go through the process again and give the painting another press.

end of the canvas to the other. Make the band broad. You're not yet a craftsman and, even if you were, the more space you create to work with the better. Besides, we're going to want many wonderful things to grow on this land, so don't box yourself into a corner.

Now all such strokes of paint I call "schmeers," which I think is more descriptive than most of the technical terms you'll find in textbooks. Critics, for example, prefer "impasto" to "schmeer" but I really think impasto goes better with tomato sauce. A more amiable term also used by some writers is "painterly," which refers to art that is full of schmeers and noticeably heavy brush strokes. Everything that you and I will be doing together is "painterly," since we are not aiming at a severely realistic technique. Obviously you cannot do a realistic painting in only ten minutes. But remember that the reputation of "painterly" art—which, after all, was practised by the likes of Van Gogh and Goya— is no less great, simply because it can't pass for photography and doesn't even try. So despise not the humble schmeer.

Over the years I've learned to create the horizontal band with a single right-to-left stroke of the palette knife. But it took me many years to develop this skill, and no apprentice can expect to do it as nimbly at first. It's not like learning to drive a car. A modicum of practice behind the wheel can enable most learners to negotiate a relatively sharp turn. But there is an awkwardness in trying to paint that won't go away as easily. I think it's totally psychological. No matter how enthusiastic the neophyte, painting still has the mys-

tique of an elitist art. This mystique discourages deftness, and otherwise sure-handed people often start to fumble.

You should therefore expect to lay on any number of horizontal strokes before you arrive at an adequate schmeer. I would even urge as many as ten strokes. Again, you never want to slop on superfluous paint, but excessive thickness is not too high a price to pay in order to master the basic techniques. After a little practice, the hardest part actually becomes knowing when the schmeer is in fact adequate. You might want to ask yourself, does this *look* like earth? Does it flow naturally, as all land does? Is its hue strong enough to suggest a rich soil, but subtle enough to accommodate the brighter and more intense colors we'll be adding later on? Of course, only after a few failures will you really develop a feel for what sorts of schmeers serve the final product and what sorts don't.

Just as, in Step 1, we touched up the abstract coat to give it depth and character, we must now in Step 2 make our horizontal schmeer a bit fancier before we move on to Step 3. The key here is to remember that our horizontal band will have a very dark look to it. In fact, too dark. Even if we plan to use a fairly bright green the sheer massiveness of the horizontal will tend to weigh down the canvas. And we don't want our trees and leaves overshadowed by a ponderous layer of somber paint pulling at their base.

It is therefore important to add touches of lively color. Using the palette knife try little specks of yellow at various places along the bottom and top edges of the band. Not only will this lighten the effect, but it will further delineate any river bank. Yellow, perhaps a dark yellow, will serve to

smooth this transition. You don't want dark earth starkly juxtaposed against blue water. Nature is most often gradual, especially when it mixes its colors. We seldom find a purely green leaf or a purely brown bark. Things flow into each other; there are no precipices of green or red or blue sticking out like rock crystals against a landscape. So by flecking your schmeer with yellow, not only do you help it fit in better with the rest of your canvas, but you create more realistic borders as well.

New artists should bear something in mind. There are moments when nature *does* actually present stark delineations—when the reeds *do* stand out like sculpted forms of green or brown against the sharp blue of the water. But just because nature does it, that doesn't mean that you should! The relationship between art and nature is very mysterious. A work that shows nature exactly as it is sometimes is the *least* realistic, most stilted and most artificial of paintings. The illusions of art are so enigmatic that, paradoxically, it is often the broadest, most "painterly" of strokes that seems most natural.

The point is, paint nature, not as it always is, *but as people expect to see it*. And that means, paint subtle colors that spill gradually into each other. I have mentioned yellow because yellow is an incredibly useful color. It can work well with just about anything else in the spectrum and is eminently functional for transitions, for softening a heavy tint, and for suggesting omnipresent sunlight.

Another color comparable to yellow both in appearance and usefulness is ochre. Ochre is wonderful because it suggests a marriage of sun and soil; its brownish hue implies

the solidity of earth while its golden tone tells us that this earth has also been subject to a sprightly dance of light. Again, have fun; there's not much harm that you can do to your schmeer with these small, vibrant points of yellow and ochre. Indeed, it was my practised use of these colors that led the great Hyman Margolis to compare many of my landscapes to Monet's *Water Lilies*.

Finally, use ochre not just at the borders, but within the body of your schmeer as well. Variations in color, especially the application of lighter colors, will create the illusion of depth in your schmeer just as the tips of the toilet paper add depth to your initial abstract coat. It is not, however, necessary to use toilet paper for any task in Step 2, although it will help.

Already we have the outline of a landscape. We have sky, we have water, we have land. And just as important, we have used lighter colors to create an illusion of depth throughout. Now comes the time to draw the actual face of nature.

Step 3

Dip the tip of your palette knife in black or a dark color, while allowing some of the paint to coat the upper edges of the knife as well. Beginning from just about the center of your horizontal schmeer draw 4- or 5-inch verticals both above and below the median. The verticals on the top half of the canvas will be our trees. The lines below the horizontal will serve as the reflections of these trees in the water. If you want to add large branches do so with identical but smaller movements of the palette knife at pronounced horizontal angles, on the upper portion of the canvas.

You do not, of course, want to be drawing straight lines. Even pine trees have subtle contours for which such rigid lines would be inappropriate. How then should you draw these trees? Imagine the skinniest "S" in the world. Duplicate that shape with your hand. Do it a few times without the knife just to get the feel of it. Then take your knife and draw the trees with just that motion.

A *common worry* among beginners is whether the reflections will accurately mirror the shapes of the trees. Again, think of how it works in nature. The ripples of the water invariably fuzz the reflections. Or the sunlight dances across the surface, bending and reshaping the trees in every possible configuration. What you see in the water is, at best, ambiguous. The fact is, you thus have enormous freedom when painting the reflections. Just follow your common sense, but don't worry if you can't render a precise mirror image. If you have drawn large branches and now want their reflections as well, merely squiggle them in on the lower part of the canvas. Once again, rigorous precision is simply not necessary.

The next question is, how many trees should you draw? Basically, it doesn't matter. We have already made the point that the landscape is an exciting genre simply because there *are* so many different routes you can follow. If your canvas is 18 inches across by 14 inches deep, a typical route would be three or four trees spaced at logical intervals. On the other hand, there are many effective paintings in which just one lone tree leans eerily off to the left or right.

There is, of course, the aesthetic issue of balance. This is a most complicated subject and we certainly don't have the

space here to explore it thoroughly. Suffice it to say that paintings should be balanced like anything else; an additional weight on the top or left should be compensated for by an analogous mass on the bottom or right. Sometimes, however, intentional imbalance can be very effective. A single tree all the way on the left may gain in power simply because it introduces a striking asymmetry into the proceedings.

The problem of balance can be approached in many ways, and it will be helpful to mention just one for your future experimentation. Through many centuries of trial and error, artists arrived at the conclusion that some colors weigh more than others. The so-called "warm" colors, like red and orange, weigh more than the "cool" ones, like blue. (To remember which are which, just associate blue with an Eskimo's lips and red with the color of a Sahara sun.) Now if you are only drawing one tree and sticking it off to the left, you can still make the composition symmetrical by adding a streak of red or dark yellow on the right. The weight of those extra-warm colors will serve to balance the tree at the opposite end.

At the ground level, streaks of red will emphasize the solidity of the land. Paint them in now. The more you learn about painting, the more you realize how complex are the problems of light. For example, after you have drawn the reflections of the trees, try drawing their shadows. A novice might guess that the problem here would be to accurately capture the actual shape of a shadow. Not at all! What you really need for a shadow is a small dark line at the base of a tree drawn in with a quick jab of the knife. Anything more

would be intrusive, whereas that brief squiggle jutting out from the trunk will tell the viewer all he needs to know.

The real problem is where to put the shadow. Its position must be determined by the direction of the light. Here light becomes a taskmaster. When we drew the reflections of the trees, we saw that the light on the water would render them phantasmagoric (optically indistinct) and thus give us more freedom in depicting them. In contrast, light dictates that a shadow must be here and *not* there, this way and *not* that way. In painting shadows we must obey its dictates. So what I suggest is that until you master the subtleties of light, it's best to assume that the sun is pouring in from the *upper left* corner of the canvas. That way, you will always be safe drawing the shadows in a left-to-right direction. I would recommend about a 25° angle from the base of the trunk downwards.

Next, touch up the tree trunks with a lighter color to once again create depth. Here, use the knife to trace just the edges of the trunks. Even a pure white will be effective for this. What emerges won't be simple depth but an actual vibration, as if the dark corners of the bark are shimmering in the sun. Our trees will seem to jump alive as a result. Next time you go to a museum notice how many of the great landscapes on view feature lakes and haystacks and trees that seem wispy, almost evanescent. The masters knew best of all what light does to solid substances, how it makes even the heaviest forms shimmer in the breeze. There is absolutely no reason why you can't achieve the same effect by simply applying subtle tinges of white to the edges of your trees.

As part of our third step, we can draw the roots of the trees directly below the trunks. Oddly enough, it really doesn't matter what color you choose. In fact the darker the tree the more I'd recommend a lighter tone. Again our real purpose is to create form through contrast and depth. Never mind that most roots are actually heavy and brown. Unless you're planning to draw the enormous vinelike roots of a fig tree, it's really more important to avail yourself of yet another opportunity to intensify the overall effect of your canvas. Indeed, there are times when a white tone, much like the one with which we touched up the edges of the trees, will be most effective.

Being true to nature with your colors is not therefore all that important. Obviously you don't want a pink sky and orange lagoon. But the real soul of art is form, and the same light that creates form also plays recklessly with color. Those roots, which we would normally expect to be brown, are subject to a thousand unpredictabilities of the sun. Any color might be reflecting upwards from the base of the trunk.

Everything you do should be with a thought towards form: light and color, composition and balance. Sculptors create form automatically by the simple nature of their materials. But in painting, there is no wood or marble looming towards the viewer, nothing extending from the surface, as in sculpture. You must rely totally on your own devices. When, for example, you draw the roots with your palette knife, be as squiggly as possible. The same narrow "S" with which you drew the trees might work.

Remember that form has been the helpless plaything of

nature for eons. It has been gnarled, torn and broken by the ravages of time, just like a checking account that is over-drawn. So pretend that your wrist is a ballet dancer. Let it shimmy gracefully at every step and thereby capture nature's form in all its uneven grandeur.

Before moving on to the next step, we want to add some character to the ground and the trees. Put a glob of paint at the tip of your palette knife. A dark color might well be advisable here. Turn and twist the knife in the paint until it looks like a string bean hanging down. Then apply it to the tops of the trees. Whether you have painted branches or just a single trunk, these additions will give much greater body to the trees. You'll really notice this in the next step, when we use toilet paper to create our leaves.

Step 4

If you look at what we have done so far, you'll notice that the first three steps have resulted in the kind of little drawing that an extremely talented child of about eleven might do while waiting for recess. You have the trees, the water, the sky, the reflections, the shadows. You can see where the land ends and the water begins. But you don't have a painting yet. It's just a picture.

The next step—using toilet paper—will make it a real painting. It's my *pièce de résistance*, the real trademark of my method of Instant Art. Just as Marconi had his wireless and John Wayne had his horse, Morris Katz has toilet paper dipped in paint. Here's how it works.

In the first step, we used toilet paper to add to an abstract schmeer of paint. As I have said, toilet paper is not just a

joke. Among other advantages it makes it a bit easier to keep a light touch, and that is very important for composing those subtle contrasts and vibrations that make a painting seem truly alive. Even some experienced artists using brushes have a tendency to belabor their canvases with too much paint. That's less likely with something as thin and wispy as toilet paper, even if it's folded over a few times.

At this point when we need to make the water sparkle, we must be able to drag a wad of toilet paper dipped in paint across the water to create the illusion of sprightly dancing ripples. The light that plays on water is an exquisite convolution of colors. It is very difficult to capture it with a brush or a palette knife. The tendency is to paint too thickly.

You can coat the thin edge of a palette knife with light blue or even white and crease the surface of the water for a ripply effect. Thin lines of creamy blue will serve to represent the ripples reflecting the sun.

But the far better way is with toilet paper. It will more easily capture the buoyancy of light playing upon water. Dip the edges of your toilet paper wad lightly in white paint and, with a loose wrist movement, swish the paper across the surface of the water just once and then step back and observe what you have done. If you've achieved what you want, make another swipe below the first one. That's about all you need to give the effect. Practise the wrist movement for it's the secret to creating a light touch.

Step 5

For the fifth step—finishing off the treetops—fold the paper until you can hold it firmly. Again, dip just the tips of the

paper in the paint on your palette. Choose light colors. Our most important consideration is that we want to create a representation of leaves, but don't just rely on green. Light red will accomplish the same thing. We'll really see what light can accomplish when you let it dance to its heart's content. Light will illuminate and exalt even a portrait. How much more will it do when your subject is an organic miracle of nature that lives and dies with the sun! So put on a little red with your green or pale blue. By the time you're done, the tops of your trees can be crazy quilts of color, a lovely swirling hubbub of leaf and sunshine with tiny patches of sky peeking through. The novice just paints an object, dull and alone, but a good artist paints it in the full complexity of its relationship to the forces around it. He knows that when you look at a leaf, a good percentage of what you actually see are other elements that are forever playing upon it.

There you are in front of your easel with a wad of toilet paper dipped in light, spangly colors. Now press the paper gently against the canvas so that you cover the upper limbs of each tree. For all intents and purposes, the relatively large circles of thin bright paint that you create this way will complete the essential part of your landscape painting.

Using the same sort of easy wrist movement, drag another wad of toilet paper, also dipped in light colors, against your sky. The more interesting the color scheme, the more vibrant and convincing will be your background.

Again, I would advise that you spend a few moments looking at the sky. Study its dynamism. The clouds pour into the blue, while streaks of color from God-knows-where

stretch across the horizon. So for goodness' sake don't hesitate to be creative with your color scheme. You'll surprise yourself with just how new and delightful an unexpected burst of orange or pink can be. Naturally, not all your dabs of color will be equally pleasing. Often you'll be disappointed by a blue that's too pasty or a yellow that's too deep. It's a lot like cooking. Even the best chef puts in too much paprika once in a while. Fortunately you don't have to eat your art, so the situation is considerably less critical.

Step 6

The final touches are done with the palette knife. They can be just as important as the preceding steps, but they are somewhat easier to do and, for many people, a lot more fun. Thus far we have learned how to paint a competent landscape. Now, if you can manage to introduce an utterly original or utterly exquisite little highlight, your finished product will be all the more effective.

The most important thing to remember is that if you decide to include a little animal or a person, not much in the way of detail is required. To put in a human figure the merest of outlines will suffice. Simply sketch in three lines with your knife edge. One vertical will do for the body. Jutting out from this vertical, two more lines at opposing 30° angles can represent an arm and a leg. It's just that easy to render an effective profile.

And yet these modest little highlights can make all the difference between a mediocre painting and a great one. It's not what sort of highlight you include, but how and where you include it. Let us assume that there are trees on either

side of your landscape. Both trees seem to dip in towards the middle of the canvas. If you've placed your person squarely between them, a most dramatic symmetry may be achieved, regardless of how crudely drawn the figure.

We have already made the point that there is really no limit to how much depth a good landscape should contain. Look carefully around your painting. Does any stretch of sky or grass or water still seem dull? Is any of it sickeningly reminiscent of a kindergartener's finger painting? After all your work and enthusiasm is your masterpiece as flat as a pancake? In other words, does it stink? Don't despair! There is always time for last-minute touch-ups. Perhaps all that dabbing we did with knife and toilet paper was ineffective. So then do some more! Lightly apply the tips of the toilet paper, just as before. A little yellow here, a pale red there and—poof!—our wan damsel's a ravishing beauty!

These then are the steps by which any reasonably competent student can complete his or her own landscape. Before I recapitulate these steps in brief outline, I would like to make a few final points.

First, don't be afraid if your wrists ache for some time afterwards. I've been painting for decades, and to this day I still cramp up. To ease the pain, pretend you're Joe DiMaggio and your hamstring hurts you. In other words, take pride in your pain, as if it's an outward sign of your professional accomplishment. Besides, haven't I told you that the world expects you to suffer for your art, or else you won't be regarded as much of an artist? Well, tell your friends and customers what hell it is just to pick up a palette knife after your muscles worked so hard painting.

Second, don't forget to sign your work. But think twice about how you want your signature to look. Toulouse-Lautrec used to draw his name as if it were a Japanese pictograph. In fact, I'd go so far as to say his signature was a work of art in itself. But if you're also interested in money—and Toulouse-Lautrec, for one, never had any—I suggest a bold hand that leaves no doubt as to who you are. My own signature usually covers a full eighth of the canvas on the lower right. My customers find K-A-T-Z spelled big and clear. Of course, if your name is longer, your signature will have to be smaller.

And third, after you've done a landscape or two, go to the museum and compare them to the masters. You're liable to be surprised by how well you've done. No, you're probably not as good as Monet, but you'll see that you're at least good enough to learn from what he's done.

Notice Monet's use of light, for example. See how the very substance of his massive solids seems about to evaporate in the atmosphere. Or study the great American landscapist George Inness. Concentrate on his greens. Stare at them as long as you can. The more those amazing shades he uses glue themselves to your consciousness, the more chance you'll have of someday being able to recreate them yourself.

Then look at the way Claude Lorrain or the Dutch masters insert small people or animals. Often they're incredibly inelegant, perhaps no better than the ones you've painted. Yet see how those faint creatures can transform the vast terrain.

Every time you paint a picture you add something to the great tradition. And that tradition exists for you to learn

from. It can have no greater or more important purpose than you.

Finally, for your convenience, here are the six steps for painting a landscape:

1. Use the flat of your palette knife to coat the whole canvas with an over-all abstract schmeer. Greens and blues should be prominent.

 Using the tips of a piece of toilet paper dab up and down lightly to lend this abstract greater depth.

2. Use the flat of the palette knife to spread a horizontal schmeer of black or dark paint across the middle of the canvas.

 Soften the color of this schmeer by flecking its edges with bright colors. Use the tip and edge of the palette knife.

 Use the palette knife to add specks of yellow and ochre to the interior of the schmeer.

3. Dip the tip of the palette knife in a dark color. Draw 4-or-5 inch squiggly verticals both below and above the horizontal. Maintain a loose grip as you draw these trees so that they will not appear rigid. Use only the tip of the palette knife throughout the rest of this third step. Break up the middle group with other colors or add warm color to right or left to create balance.

 To draw branches, sketch in similar, equally squiggly lines at horizontals of about 30° from both the upper and lower verticals.

 For shadows, draw in small dark lines at an angle of about 25° from the base of the trees. Draw them down-

wards from the trunks in a left-to-right (or right-to-left) direction.

Touch up the edges of the trunks with a light color.

For the roots draw in small squiggly lines just below the trunks. If your trees are especially dark, use a light tone for the roots.

Touch up the upper portions of the trunk and/or branches with a dark color. Use a thick blob of paint.

4. Using only the tips of a light wad of toilet paper, dipped lightly in white paint, swish it several times across the blue water to create sparkling ripples. Use a loose wrist movement. If you can't get the right effect this way, use the palette knife to crease the surface of the water with light blue paint to represent ripples.

5. Dip the tips of a strip or wad of toilet paper in bright colors. Press the paper gently against the treetops to create spangly clusters of leaflike circles and other shapes.

6. If you'd like, add a stick figure of a person or animal. Place it in as subtle or as dramatic a position as possible, vis-à-vis the trees or water.

If not, touch up with yellow or ochre wherever you need emphasis. Use more toilet paper to add light colors to any spots on the canvas that still seem flat.

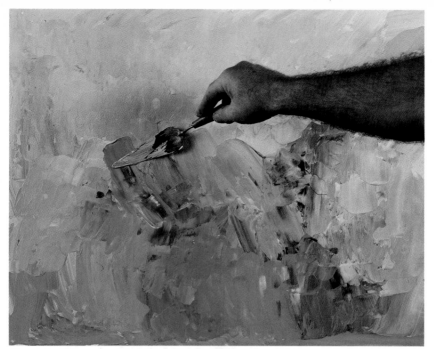

Step 1. Blues and greens "schmeered" with your palette knife and lightened by use of your toilet paper wad will make a good background.

Step 2. With one left-to-right stroke of your palette knife, paint a horizontal band across the middle of your canvas, then add verticals both above and below this ground and water line.

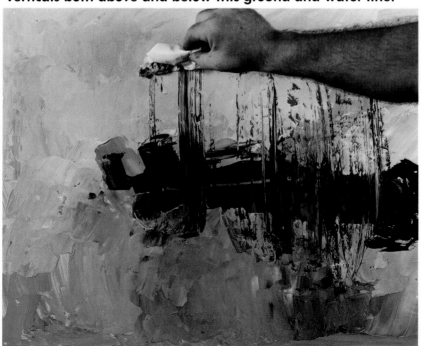

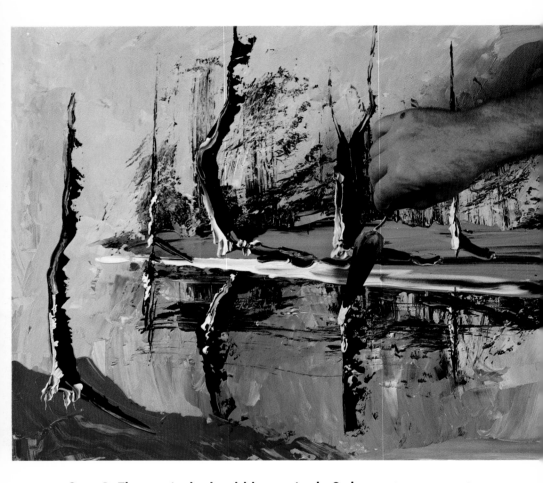

Step 3. The verticals should be squiggly S-shapes to represent trees, not straight up and down. The shadows depend on where the light is coming from. Touch up the tree trunks with white to give them a shimmering depth.

Remember that color gives weight and warm reds are heavy, so balance them. Balance is always desirable but placing a tree eerily off to the left or right can create asymmetry.

B

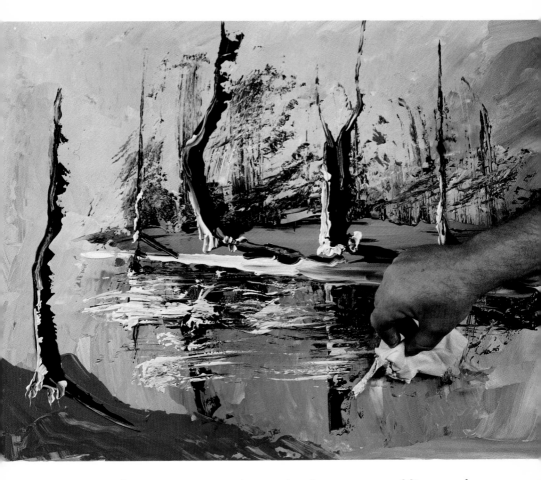

Step 4. At this stage, we need to make the water sparkling, and this is where a sweep of the wad of toilet paper dipped lightly in white paint is needed. With a swish of your wrist from left to right (or right to left), you will open up highlights and ripples. Now you can turn your attention to the treetops and create sparkling red leaves with your toilet paper, this time dipped in red or yellow paint and then pressed on the canvas.

C

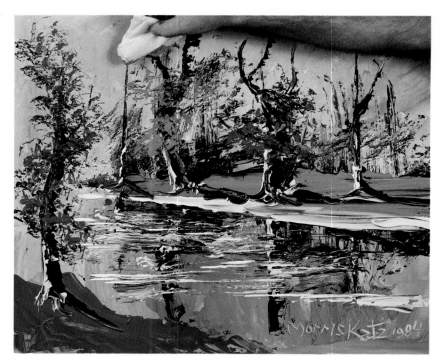

Step 5. Add leaves to the trees with the light pressure of toilet paper loosely wadded and dipped in thin red paint.

Step 6. Finishing touches can include the addition of a figure or animal. Or, as here, you can "hit" spots with yellow to bring up highlights with a heavy layer of paint on paint.

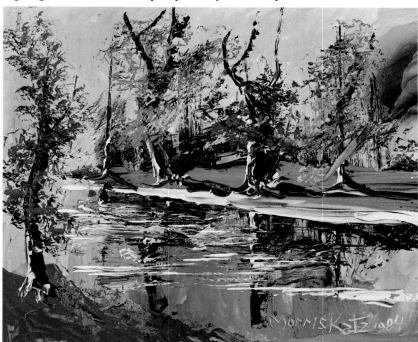

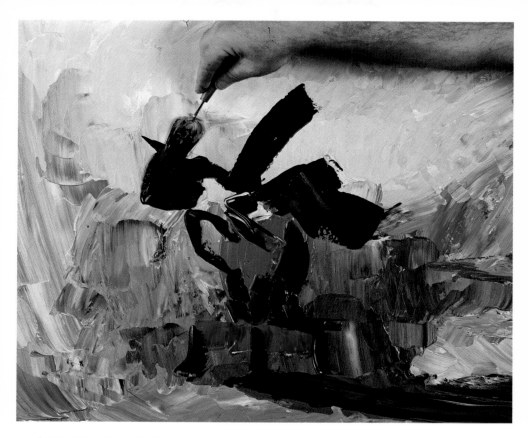

STILL LIFE. Step 1. Cover the canvas with abstract using the flat side of your palette knife for this blocking in. The background here, unlike the landscape, will not be used for sky or water, and you have no limits, but remember that you won't want the background to interfere with your subject.

E

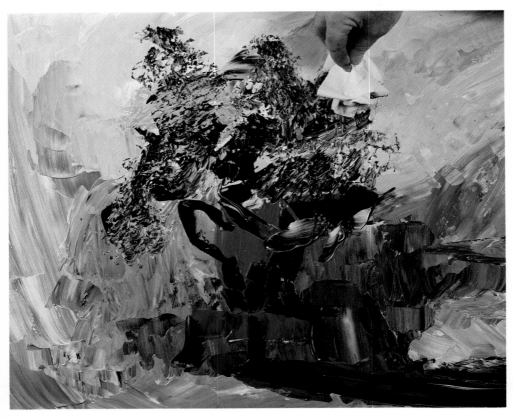

Step 2. More blocking in, first in the middle, where your flowers will be, and then some swirling around with the toilet paper to break up the mass and pave the way for the flowers.

F

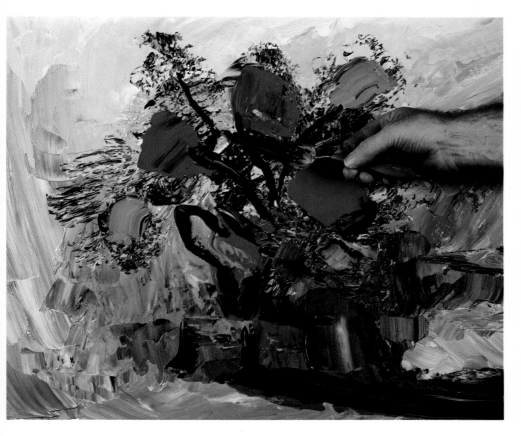

Step 3. Paint in the roses—no more than five is best—and make their color as vivid as you want at this stage. Starting with blobs, draw down the color with your palette knife into stem lines. When you've gotten the shape you want, dab at your reds with toilet paper dipped lightly in yellow or green. Touch up the stems too.

G

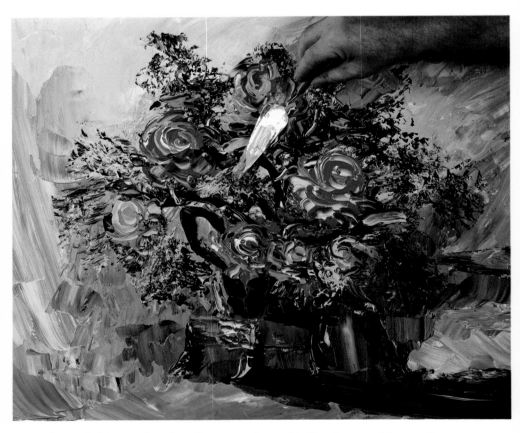

Step 4. Using the tip of your palette knife, draw with semi-circular strokes the outlines of the roses, and, with white and a bit of red, touch up the curls of the petals. Do this as gently and thinly as possible. Touch up the legs of your container, and use yellow to contrast with the bright reds. Sign your work.

H

Chapter 4

Still Lifes Are Never Still

Before I give you the four steps by which you can paint a competent still life, I want to share with you some of my thoughts regarding this genre. Hopefully my observations can increase your sense of purpose—your sense of the importance of a still life—as you sit down and attempt to paint one.

A lot of people look at still lifes and say, "What's the big deal?" They prefer landscapes, which are clearly subject to a thousand variations. Even the most prosaic imagination can grasp just how original and dynamic any given scene of sky and surf can be. Still lifes seem repetitive in comparison. What can we learn or enjoy in one arrangement of flowers or fruit that we haven't already experienced in another?

The fact is, we can learn more about art from a still life than from any other kind of painting. First of all, no two of them are alike. It is through training our eye to pick up the subtle variations that we become really attuned to the thousand small factors that make art art. Anyone can look at two cityscapes, for example, and perceive obvious differences, even when the works depict the same corner of the same city. (Compare, for example, Joseph Stella's *Brooklyn Bridge* with John Marin's.) The vastness of a city is such that there is always room for contrast between any two renditions of the same scene. But there's so much more to learn from observing the equally significant differences between two still lifes. Once we absorb and internalize those differences, we will be on our way to true artistic sensitivity.

The arrangement of a good still life can be as dramatic as a scene of ramshackle sheds blown by a tornado. Envision a

strip of canvas about 5 feet by 5 feet. Space is precious. A small rose drawn in at any point is going to loom on the scene like the Sword of Damocles. The surrealist René Magritte, for instance, once painted a single apple abutting each border of the canvas. That single apple was like an avalanche of form, almost oppressively ponderous. There was no doubt about it; *it was there*. Similarly, any one ingredient in a still life will carry enormous weight. If you bend a petal an inch this way, or incline the table a foot that way, the permutation will be earth-shattering. The point is, nothing is inessential in a still life. Every decision you make is vital. That's why it's so interesting, and why you get such a profound feeling for art by practising in this genre.

We have already noted in our study of landscapes that form is the soul of art. In a still life, each arrangement creates a different form. Two apples to the left of a pear constitute one total form; two apples on the right constitute another. Yet these forms are by no means static. In every good still life there is movement. One has not really succeeded in rendering a dish of fruit well unless the dish seems to swirl or rock gently with steady, eddying vibrations. In addition, there should be some sort of tension or dynamic relationship between the dish and what sits in it. Perhaps the fruit is sailing off with it, or perhaps the fruit's solid mass is doing everything it possibly can to resist the agitation of its container.

And finally there is texture. Should the fruit be as smooth as glass—like an ideal fruit in Eden before the Fall—or should we once again opt for realism and capture its rough texture, bruises and all?

Now I'm not trying to scare anyone off from the still life. They're just as much fun as they are instructive. I am, however, trying to dispel any notion you might have of the still life as a perfunctory exercise, or as something plebeian that hack painters rely on whenever they don't feel up to doing a landscape or a portrait. There is really no point in my trying to teach you how to paint a still life unless you first have a sense of its vital role in art history.

Indeed, most of the great painters of the world did still lifes at one point or another. The masters were aware of the same challenges in form, movement and texture that we have touched on. Even more telling is the fact that the great revolutions in modern art have been ushered in by men experimenting with still lifes. I would like to mention briefly two such instances in our recent history before getting into the relevant methods of Instant Art.

The greatest of Paul Cézanne's masterpieces were still lifes. If you look carefully at them you'll notice remarkable things. Apples bisect whole tables. Tablecloths take on the appearance of icy waves. Nectarines are intentionally deformed until they seem eerie oblong planets reverberating in deep space. Yet Cézanne represents only the first stage in a revolution. Later came the cubists, Braque and Picasso, who were obsessed with the need to re-examine the way we look at things. And how did they instigate their epoch-making re-examination? With the still life, of course! In fact, for nearly a decade those giants of early cubism worked on little else besides their still lifes.

I mention these revolutionary still lifes, not merely to reiterate the importance of the genre, but to suggest what

you yourself might ultimately be able to achieve. All the great still life artists were driven by one overriding consideration: *to discover secret form*! There are supremely elegant angles and mystical intertwinings of circles and ellipses behind every petal. Cézanne, as much as any man who ever lived, wanted to uncover those mysteries. A Cézanne, of course, might come along but once in a century, yet I believe that if you apply yourself to your still lifes—if you concentrate on a floral as you would upon the face of a madonna—that inner dimension might one day hop right out at you.

Gurus and yogis and holy men spend half their lives staring at flowers in order to discover the spiritual beneath the physical. But now, thanks to Morris Katz, you can draw a flower in four easy steps and, who knows, the same wisdom that the Maharishi Yoho hums and chants and chomps to get at can be yours in the flick of a wrist.

Step 1

Using the flat side of your palette knife once again, coat the whole canvas with paint. While this is the same procedure as with the landscape, there's also an important difference. Our background here is *just* background. It will not also be utilized for sky or water or land. This means, of course, that we can really afford to be creative. Paint whatever colors strike your fancy, but remember that too much bright color may overwhelm the final product. You don't want your audience more interested in abstract swirls of pink and yellow than in the red of your roses or the blue of your berries.

In fact, for the first few efforts, I suggest that you use black and white for the abstract background. Aside from guaranteeing that your floral will not finally be overwhelmed, you will also gain some good experience working without color. Later on we will devote a separate chapter to the black-and-white, but suffice it to say for now that it's just plain fun to work in the most basic medium.

Step 2

After we are through painting the abstract background—the technical term for this Step 1 process is, by the way, "blocking in"—we can jump right in and draw our container or vase. Again, use the flat of the palette knife to paint an oval or square schmeer. I suggest a pale bright color or a soft brown, but you've seen a few thousand still lifes in your time, so choose what color you like.

In this same step we will put in the flowers and the table, but remember that we don't *have* to have a table. Our vase can, if we wish, be suspended in mid-air. It can float in the middle of the canvas as if the plane of the picture space were itself a solid mass capable of supporting the weight of our subject.

This was one of the significant innovations in art around the time of the Baroque. Velasquez, for example, did a great portrait of a court jester who seems to be standing in the middle of nowhere. There is only the hint of a floor. Yet it looks realistic. While the absence of a more solid mooring does suggest that the old clown is rather pathetically lost in space, we don't really notice it all that much. The canvas itself is enough for him to stand on.

I mention this before we get further into Step 2 in order to give you an even better idea of just how important your abstract schmeer can be. Background, you see, isn't always just decorative. It creates substance and weight; it is a part of the vital interrelationship of the elements in your design. This, I would suggest, is one more reason to do it in black and white, at least at first. With black and white you can be sure it will ultimately support your final design if it has to.

Now paint in the table legs with the flat of your palette knife. Again, it is not advisable to paint lines that are too smooth and rigid. It's easier, more fun and better-looking in the long run to do thick and knotty legs that sit python-like beneath the flowers. I use an easy and emphatic wrist movement for optimum results. Actually if you give your table spindly, straight little legs it will look as though you got the table for $30 at Sears. And then people will say, "Oh, this artist doesn't have any money! I bet I can buy his still life for a song!" On the other hand, if they think your table is a rare antique they'll be ready to pay more for your work.

Another circular schmeer with the palette knife above the vase will create a rudimentary design for your floral. This should be a single large application of bright paint. It is not yet actual flowers, but it will set the tone, the texture, the color, the substance of what will become flowers. We can again use the phrase "blocking in" for this process. Strive for as round a formation as possible. A round, robust blob will give us a lot more leeway when we finally draw in the exact form of the flowers in Steps 3 and 4. That can be a somewhat demanding process, so the easier we make it for ourselves now, the better.

There are probably too many hard edges in your design, so use the tips of your toilet paper to dab the borders of the schmeers. A slight blurring of the edges is desirable to soften the picture. Moderate overflow of colors is likewise a pleasant touch.

Step 3

Use the palette knife to go over the floral area and paint in approximate forms of flowers. Step 2 gave us a generalized circular schmeer containing many potential shapes. In other words, Step 2 was more or less one big ball. Now in Step 3 we use the flat of the palette knife to divide that blob into however many floral sections we want.

We thus make our basic decisions in Step 3. Now we are really determining how many flowers we will eventually have in the picture. We also decide what color our flowers will be and whether they will be roses or azaleas or whatever. None of this is irreversible. Anything can be painted over. I do, however, encourage you to make as shrewd a choice in these matters as you can as early as you can. It's never good to waver and be constantly starting over again. If you make up your mind early in Step 3, and stick to your choices, you will gain in energy and concentration as you move on to the more difficult task of Step 4.

I always urge students to be flexible and to experiment, but for novices I would suggest that three or four flowers are probably ideal. More than three or four will most likely be too strenuous at first.

Oddly enough, though, *fewer* than three might be even

harder. This is because the viewer's attention will be more intensely focussed on the details of the individual flowers. People will expect a single flower to be more realistic. They will be more prone to scrutinize its petals and examine its stamen and cross-examine its corolla. And I don't even know what a corolla is!

In addition, how you pose one or two flowers becomes even more crucial than when you draw in three or more. You don't want a single flower to have to carry such enormous weight. (Remember our previous discussion of balance.) It must sit in a vase atop a table. If it dips in the wrong direction or if its stem isn't a heavy enough color, it might well get lost altogether.

With three or perhaps four flowers you elude the compulsions of such rigor. In a few years, perhaps even a few months, you can tackle these formidable problems, but for now your goals are basically to teach yourself and please others. I would therefore suggest that you also keep things simple when you choose your flower. Now what can be better than a rose? Roses are easy because there's really no limit to how bright a red you can use. People expect roses to be as red as you can make them, and they love it when they are.

Rhododendrons, azaleas and their myriad friends are always fun and worth trying, but the shapes of those flowers are more difficult than roses and the colors more varied. Of course you don't *have* to have a specific variety in mind when you sit down to paint—you can leave the genus to serendipity—but I've noticed that people enjoy being able to recognize a flower. "Oh, that's a wisteria," they'll exclaim,

as pleased with themselves as with the painting. And of course there's nothing wrong with this. A vital purpose of all art is in fact to make the viewers or the readers or the listeners recall things they already know. Yet I tend to stick to roses, because the same people who delight in identifying rare varieties of hyacinth are just as exhilarated by the deep, deep red of a red, red rose.

Next we pull the palette knife downwards from the blobs in a vertical direction. This creates the stems and lends a suddenly recognizable form to the whole. Of course, you might find it interesting to modulate these verticals with somewhat horizontal variations. This will make the flowers appear to be bending or falling; other sorts of slight horizontals can make it seem as if they are tumbling forward, towards the viewer.

The ends of the stems should dissolve in the vase. Remember, the essential shapes of the vase and table are already complete in the blobs. You may, of course, choose to adjust or sharpen these forms at any time during the third and fourth steps, but I don't usually care to alter their rugged power. Of course, neither the vase nor the table should be too vague for the viewer to identify it quickly.

Step 3 concludes with more toilet paper. Regardless of what color we have chosen for our flowers, we now want to dab them with a lighter color for depth. This is precisely the same technique we applied a number of times to our landscape. For the florals, a dark yellow will do just fine. Of course, these still lifes, which already feature such pronounced colors, do not require much additional vibrancy. In

fact, I'm usually fairly reserved in my use of lighter shadings at this point.

I am, however, less chary of touching up the stems. Take your toilet paper and dip it in yellow or light green or even pale red. Once again, an ochre will also be effective. Dab the stems at various points; these dabs will serve to represent tiny protruding leaves or miniscule blobs of tissue growth. A spiny stem is not only realistic, but will also work well as a transition between the bloblike massiveness of the vase and the greater delicacy of the flowers.

Step 4

Now we come to what is probably the most challenging single step in either the landscape or still life process. Yet, as with so much in art that seems unusually difficult, the rewards can be commensurately great.

Using the tip of the palette knife, gently draw in the actual features of your flowers. Apply smooth semicircular lines leaving more or less equidistant bands of space between them and the edges of the blobs. The lines should be as thin as possible, but be readily perceptible as well. What you are really doing now is etching, and if you think of it as such, rather than as painting, it will probably seem easier. Here it's particularly evident what a boon the palette knife is to Instant Art. With a brush, this "etching" would be a most painstaking affair.

These features should be painted in light tones regardless of what other colors you're using or what variety of flower you've chosen. It's the temptation of many novices to assume that a dramatically chiselled black line will look ter-

rific against the stark red of their roses. I guarantee you it won't. But a subtle pink or a strong yellow or even an off-white will be most effective.

Just within the arcs of these lines etch in smaller ones. These should be semicircular or semioval, with a circumference of around ¼ inch. Again, you want light tones here. I would suggest something analogous—meaning close on the color spectrum—to the colors of your larger lines, and perhaps a bit on the darker side. If you've etched a dark yellow, for example, make its smaller companion a similar yellow with just a tinge of pale green. Or if you've drawn one that's off-white, add a pale yellow beside it.

I should make a point here to avoid any confusion. While I might happen to use a word like "analogous" in its correct scientific sense, I seldom do so with words like "tone" or "hue." The way I use those words is the way the dictionary defines them, not the Academy of Painting.

One crucial point to make is, don't etch in the lines on the blobs until the blobs have dried. This is much less obvious advice than you might think. Many artists, myself included, do not wait for a schmeer to dry before adding more onto it. In my case, I'm impatient because I'm trying to break the time barrier. But other artists who are as slow as molasses intentionally practise this so-called "wet-on-wet" technique because it increases the agitated, "painterly" look. This painterly style first became possible when people like Delacroix started painting directly, without benefit of tempera undercoatings. Wet-on-wet is the ultimate in dramatically direct painting, but if you try it too early in your career you'll wind up with a miserable gooey mess.

When you etch in these lines on your blobs, start thinking about mixing colors. This is a subject that really requires its own book, but for now my advice is to have a good time. Be a child again and just mix your tones until something strikes your fancy. Children have the sense that if they combine things in a fresh way—whether paints or the spices in the kitchen cupboard—they'll discover America. In fact, they might. I have seen colors in paintings that I'm sure have not been duplicated since. Earlier, for example, I mentioned the American landscapist George Inness. I defy anyone to find me another green like his!

The mixing process is especially important for the light-hued tones of Step 4. As long as your tint is not outlandishly inappropriate, you're liable to add to the deep red of your rose a unique yellow or orange that will rival any master's great bold stroke. Just stay away from shocking pinks or blinding violets!

Concentrate on mixing the lighter colors: the reds, oranges, whites, yellows and some greens. These are the colors that promise the greatest return. Why?

Because the most you can achieve with any strange hybrid of darker colors is just *one* more new and interesting shade. That's always nice to have, but it's with the lighter colors that we add many shades of depth and vibration to everything we paint. Think then of innovating, of a radical change in concepts, an entire new genre of art that may come about, simply because we've outlined a rose or a tree or a vase or a river with a unique tint of yellow that no one's ever seen before! Those kids mixing spices in the kitchen are right. Once you start fooling around anything can happen!

It's always a good idea to "steal" a little color from your florals and add it onto the edges of your vase. This lends coordination and a feeling of unity to the whole. Remember that there is more to the juxtaposition of colors than merely asking if one color "goes with" another. We're not just buying neckties after all!

In art there must be a mysterious sharing and intertwining of themes. One thing must foreshadow another or reflect on what came before. So if you have a sharp red in your floral blob, dab a bit on the vase and do the same with the lighter colors etched in on the petals. The viewer should have the sense that the vase and flowers don't just match, but suggest and lead into each other as well.

Now take your toilet paper and dab the bodies of the flowers with analogous colors. Suddenly there is depth—quite unexpected!—and suddenly there are vibrations. What you had thought was a rose was really only a bud. But now it flowers! Now, with this last little touch, the floral seems to actually increase in size. Of course it doesn't; it simply increases in dimension.

Apply the toilet paper to the vase and to the table as well. Here the new vibrations will enhance our sense of volume, and of the solidity of the pieces. Notice finally that one of our most important criteria has been happily met. There is *movement* here; there is a truly dynamic relationship between these vibrant flowers and the small, precious world in which they thrive.

The final touch-ups are, again, up to you and should express your individuality. I might suggest, however, that you utilize a bit of leftover background and paint an abstract.

Use no more than 2 inches square in the corner of the can-
vas. You may want to introduce a totally new color here, or
you may want to subtly reiterate one or more of the others.
A truly masterful touch would be to work in a slight re-
semblance between the tiny abstract and the floral. Such an
unlikely mirroring effect would be an intellectual *coup de
grâce* if you can manage to pull it off. But if worse comes to
worse, adding the abstract is a great sales gimmick, because
you can always tell your customers they're getting two pic-
tures for the price of one.

I began this discussion of the still life by noting the spir-
itual impetus that drives us as we work, the search by giants
like Cézanne for the secret form behind all matter. Perhaps
our techniques here may give you some advance intimation
of how powerfully that "secret form" preoccupies the still
life painter. A word like "blob" is a very fortuitous one, for it
suggests a Rorschach monstrosity out of which anything,
from a lily of the field to a carnivorous flytrap, might derive.
If you can look at a blob and see both, you're already an
artist and may one day become a prophet.

That blob is the "oversoul" of all flowers, their common
source and permanent substance. But each flower is also
unique; the artist undertakes the cosmic chore of articulat-
ing the uniqueness. The "etching" process, by which we
turn the blob into a rose, is often gruelling beyond en-
durance. I can only give you hints, but your steady hand
and eye must find their own way. Most artists refuse to give
you even a hint. They'll ask for your guild papers instead.
When they ask *me* for *my* relevant documents, I unravel the
toilet paper!

Before moving on to a brief discussion of black-and-white, let us now recapitulate the four steps for painting a still life.

1. Use the flat side of the palette knife to coat the whole canvas with an abstract schmeer. Any color will do; black and white are recommended.

2. Use the flat side of the palette knife to make an oval schmeer for the vase. A pale bright color or a soft brown are recommended.

 Use the flat side of the palette knife to draw table legs. Avoid rigidness. You don't *need* a table.

 Use the flat side of the palette knife to apply a bright circular schmeer from which the floral will derive. Emphasize roundness in the design.

 Use the tips of a piece of toilet paper to dab the borders of the schmeers. A blurring of the edges on all three schmeers is desirable.

3. Use the flat of the palette knife to divide the floral blob into as many sections (flowers) as you want. Three or four are suggested.

 For the stems pull the palette knife downwards from the blobs in a vertical direction, or vary with horizontal or semihorizontal angles.

 Dab the floral with toilet paper. Use light colors, but apply lightly at this point.

 Touch up the stems with toilet paper. Use light colors.

4. With the tip of the palette knife, etch in smooth semicircular lines on the face of the blobs. Use light tones.

Etch in smaller lines, semioval or semicircular with a ¼-inch circumference. Choose colors that are analogous and slightly darker than the ones already etched in. You might want to mix your own light colors here.

"Steal" a little color from your floral and add it to the edges of your vase.

Dab the florals with toilet-paper tips dipped in analogous colors. Apply tips to edges of the vase and table as well.

Draw in a little abstract as a final touch-up. Use no more than 2 square inches at the bottom of the canvas. Perhaps make the abstract resemble the floral.

Chapter 5

Leonardo da Vinci Meets Harry Houdini

Color has been one of the main preoccupations of artists down through the ages. Mankind has lent the subject such enormous concentration and explored its subtleties so energetically that one might not necessarily guess that black-and-white has remained a viable and powerful alternative. I have done a lot of work in black-and-white, and it is appropriate that I now use just a few pages to discuss this medium in terms of our four steps.

Why, first of all, is black-and-white so potent a medium? It is, really, because you are confounding people's expectations. After all, they've been staring at colorful landscapes all their life. A good colorful one will please them, of course, and if it is very, very good, they may be astonished as well. But they won't necessarily suspect divine intervention, no matter how well rendered your tricks with form and depth and light.

Yet when these same people see that same scene rising out of elemental black-and-white, they will attribute it to nothing less than pure magic. In some ways magic lies at the heart of all painting, but nowhere more so than here. When people look at a good color landscape they praise the talent that can create such loveliness, but if the identical scene works in just black-and-white they wonder what manner of man is able to make a greenless tree seem so real or a plain bud seem to smell so sweet.

The connections of magic to black-and-white are numerous. Remember that most of us dream in black-and-white. They are the colors of our fantasies, of the unexpected, of the unreal, of that which we crave and that which we dread. To paint effectively in black-and-white is to secretly re-enact

last night's dream, both for ourselves and for our audience. They won't know it, of course. They'll sit before us innocently watching as we dredge up their innermost images—and their amazement will be proportionately great.

Black-and-white is likewise the color of memory. Even if we are remembering a gorgeous scene in the country, the colors of the trees are always muted in comparison to the brilliant originals. And when great thunderous ideas are dealt with in our mind—crashing conflicts of one opinion about life in the universe versus some other—the tone of the imagined confrontation is always black-and-white. So, of course, a colorless drawing or painting done effectively will always be a potent force to reckon with. This seems obvious, yet it will capture the innocent spectator unaware. Even less innocent people like myself are still stunned when we come upon a Rembrandt sketch whose unembellished lines seize us heart and soul.

Indeed, are there not great movies still made in black-and-white? The technological facilities for deep color are unlimited, and one would think that in so competitive a market as the movies no producer would dare take a chance on black-and-white. Yet the appeal of the grainy old style remains and directors like Woody Allen insist on using it.

I remember an art show of mine not long ago when, towards the end, I said that I would now do a final picture in black-and-white. I could feel everyone behind me beginning to relax. They seemed to think that my real work was over; I had done my twenty or thirty paintings in color and would now just diddle around a bit with a trivial sketch or two before heading for home. Yet when I finished I could hear

them actually gasp. The realism of the scene and its evocative power had caught them with their guard down.

There is, finally, something in the medium itself that works towards magic. Black and white are not, after all, so very simple. White is really the presence of all colors; black, their total absence. That's pretty powerful stuff when you think about it. Far from neglecting color, you are simultaneously playing with all the colors in the world in a mysterious, invisible, even mystical sort of a way. All the greens and blues and reds are allied there on one side, hiding in the white, posed against the black nothingness. My guess is, if anyone survives to paint World War III, they'll do it in black-and-white.

I will now give you the four steps for an effective black-and-white. I will use a simple landscape for the demonstration.

Step 1

Apply a black-and-white schmeer across the entire canvas. I suggest that you keep your tones relatively mild here, since we don't want our final drawing to have to compete with the background. Indeed, it is really only when doing landscapes in color that a prominent, even startling abstract schmeer is desirable. Here I suggest that you allow your blacks and whites to overlap. Dab them against each other until you get some nice off-tones. The more sensuous, the better.

Step 2

Draw in black verticals with your palette knife. Remember

that these tree shapes will have to carry the burden of your design. There are no stark contrasts in color to emphasize the line. So don't hesitate to paint these with a darker tone than you might normally choose. Extend the trunks well below the center of the canvas to further emphasize mass.

Step 3

Use the palette knife and toilet paper for the leaves. Apply both black and white with the palette knife. Draw in the leaves semiovally, or imagine little upside-down umbrellas as your model. Dab them with toilet-paper tips dipped in white. You'll find that the vibrations which we sought to add onto the landscape and still life will now appear almost automatically as soon as you touch the canvas with the paper. This is because the white flecks will be forming such sharp contrasts to the heavy black of the trunk and the soft dark of the background.

Step 4

For final touch-ups add a little house or person halfway between the trees and the far end of the canvas. If you choose to do a house, draw it in with your palette knife by imagining a broken box as your model. Simply draw a wiggly rectangle with the top line indented downwards.

If the canvas seems flat, touch it up with additional dabs of white using the toilet-paper tips.

Since the black-and-white has introduced us to the subject of magic, I'd like to raise here a related topic of equal importance: the appeal of Instant Art in general and what it can do for you in your life.

There must be a reason why so many newspapers and TV shows continue to seek me out for demonstrations. If Instant Art were only a gimmick, all interest in it would have died out long ago. Even in the Catskills, I'd be old hat already. But the media "mavens" have been calling me for many years now and their curiosity does not seem to be flagging.

While I have emphasized the black-and-white as the most magical of paintings, there is a general magic that is related to all of Instant Art. It works like this: *presto, a painting*! Speed is a necessary ingredient in all stage magic and I do do most of my art on stage. The appetite for magic in this world is constant. It may not be as commonplace a form of entertainment as the musical comedy or the cops-and-robbers show, but it is a much older form and will no doubt outlive the majority of its competitors. Again, what I do is a magic act, and no good magician is ever out of work.

Understanding Instant Art as magic tells us a couple of things about it. Think for a second about how magic thrills all children as well as most adults. It's an almost physical sensation you get in your gut when the magician pulls the rabbit out of the hat—as if you were riding on a roller coaster. My art gives audiences the same exhilaration. At the very least we can say it is simple fun, which is a rare commodity these days. Now combine simple fun with legitimate art and you have a unique product. Michelangelo without his religion, Goya without his rage, Rembrandt without his wrinkles—that's old Morris Katz! In other words, it's great art that's fun for the whole family.

Magic, fun and art are, separately, good for what ails you.

Now imagine all three together! What a brew! The most important function of Instant Art for the consumer was summed up nicely by Arlene Francis when I was on *What's My Line?* "My goodness," she said, "this *is* therapeutic!"

Therapy, indeed! And who thinks more about therapy than Americans? The United States in 1984 is obsessed with it. Look at all the weird experiments! Psychiatry is commonplace by now. There's the Rev. Moon and Dianetics and est and a crew-cut young guru in California who's made national news by teaching his disciples to walk on hot coals. For a fee you can go to New York and find God, or if you prefer, you can try California for inner peace and self-discovery.

Now look at what I offer instead! For a small fraction of the price these holy people charge, I am teaching you how to paint a landscape that's guaranteed to settle your stomach. I don't claim that Instant Art will solve all the problems of your life, but I do promise that if you have fun making a pretty picture, you will *certainly* be a better person for it!

This is also why so many different sorts of people enjoy Instant Art. Arlene Francis is, of course, a very sophisticated lady and I'm sure if I took her to a museum she'd be able to tell me a thing or two about the pictures hanging there. But her enjoyment of my work was unequivocal, and for all the right reasons. She knows that an overpressured executive with migraine needs me a lot more than he needs Mantegna or Giorgione. And she knows that there is no social or cultural stratum that cannot be reached with Instant Art.

Now I'll tell you about a miracle. I once met a man at the

Nevele named Saul Blitzstein. He was overweight, balding and, I must say, rather unpleasant to deal with. In fact, I let him have $30 off a still life just to get rid of him. But he came back the next day and said, "You teach me to paint like you."

"Terribly sorry," I smiled, "but I'm busy, busy, busy . . ."

"I'll pay you—," and he named a most tidy sum indeed.

"Since you're so determined," I said, "I guess it would be *immoral* of me to resist!"

Mr. Blitzstein was an apt, if sullen, pupil. In less than forty-eight hours he knew at least as much as a careful reading of these pages will impart. A year went by and I forgot him. One day I was taking in the Greenwich Village art fair. "Hello there," a cheery, robust voice boomed out. "You, Katz there! Hello!"

I swear I did not recognize this man. It was a moment or two before I said, "Blitzstein, is this *you*?"

Yes, it was! Some of his hair had grown back. He had lost a good twenty-five pounds and could have passed for Benny Leonard! His eyes were twinkling and his smile shone broadly.

"Blitzstein," I said, "you've become a scintillating person!"

"And I owe it all to Instant Art," he said. "I gave up the insurance business and now I just sell paintings. I sell a painting a day and I live like a king. I even got married again. I'm so happy! Katz, how can I ever thank you?"

Yes, it was a miracle! But now I'll tell you another story that is so revealing it will blow the lid off the whole art world. There is a famous abstract painter named Willem

de Kooning, who is the favorite of all the hotsy-totsy critics. They live and die with each stroke of his brush. Well, I learned from an unimpeachable source that late at night de Kooning secretly practises Instant Art in the privacy of his East Hampton home. By day he does abstracts with a brush to please the critics, but at night he does seascapes with a palette knife to please himself.

Nor is de Kooning alone in living this double life. For many years I was noticing the same lovely lady at my shows. She would always sit in the back and wear sunglasses. She was clearly a woman of mystery, travelling incognito! Discreet inquiries to the hotel desk revealed that it was Helen Frankenthaler, also a very famous and great abstract painter. Apparently Ms. Frankenthaler lives and dies with my art, but is afraid to admit it for fear of offending powerful critics.

They'll deny all of this, of course, but I have never needed their praise. I have already established myself as an artist and I have likewise made a fair amount of money. My real ambition now is to spread the gospel of Instant Art to you and the far corners of the globe. Let the message of Morris Katz ring clear! Bantus, Hindus, Hottentots! Hear ye, hear ye!

Chapter 6

The Simple Subject of Supplies

The subject of supplies is a most threatening one to so many people who would otherwise jump at the opportunity to try their hand at painting. What supplies to get, how much to spend—in fact, these questions are not half as troublesome as you might think. A few practical hints might prove useful. Of course, it's always good to get the best and the cheapest—just as with anything else—but don't be nervous! Everyone makes mistakes and if one day you get stuck with an inferior bit of canvas or a second-rate tube of paint, Rembrandt's ghost isn't going to rise from the grave and consign your work to perdition.

In every field there are merchants anxious to help a customer who doesn't know much, and there are also merchants who are contemptuous and will treat you like dirt. Ever buy a car, for example, or a camera? Retailers in the art supplies business tend to be considerably more helpful than their counterparts in those industries.

If there is one chore related to supplies that you might find genuinely formidable, it's buying canvas. You need a lot of it and sooner or later you'll be making a real investment. This is one of the main reasons why art students are even poorer than struggling writers or out-of-work actors. There's no way around it; to study art seriously, as I did for so many years, requires a major commitment. If, by the same token, you're practising Instant Art rather than undergoing the more conventional ordeal, then most of your other expenses are cut all the way down the line. The burden of the canvas isn't quite so heavy if you're spending less on everything else.

The first thing that will startle you when you walk into a

supplies store is the incredible variety of brand names and materials. And these aren't just variations in labels either; the products all look so different that you suddenly realize *it might actually matter what choice you make*! Well, yes and no. What matters most, really, is that you feel comfortable with the product. If it's a palette knife, for example, handle the thing! Do you like the way it feels? And never, never spend more on anything than what you can afford.

The easiest thing to buy is the easel. Just ask the merchant for a good one. Then, if it seems OK to you, get it. For canvas, you'll need to be a bit more careful picking a merchant. Ask an artist friend to suggest one. Or walk into any Sam Flax-type of store and simply tell them the sizes you want and how many paintings you plan on doing. I've never known the clerks at a fully-stocked art supply store like Sam Flax's to be dishonest or impolite.

The palette knives are cheap, so we can afford to experiment. Simply ask for flexible steel palette knives. I have settled on one variety, but it took me years to find it. You should use as many different ones as possible, particularly during your first few months. Even if you find one that you like, don't stop there. Try a few more brands and you may come upon one that feels even better.

Just because I use one palette knife for all my different subjects doesn't mean you have to. Over the years you may find one knife that's best for landscapes and another that you prefer for still lifes. I do suggest, however, that you keep at least two sizes on hand. A large palette knife with a good flat surface will do for your schmeers and blobs. A smaller palette knife with a nice sharp point will, on the other hand,

suffice for drawing in the trees, the roots, and other detail.

To anyone who's never done it, the prospect of buying paints must loom dreadfully. Paint quality is indeed most important, since a weak-bodied or chemically insufficient paint will ruin all your work. And if watercolor trays at Woolworth's for the toddlers are all you've ever bought, I can imagine you're at sixes and sevens. Indeed, one of the major professions in the art world today is restoration, not just of canvases that have been damaged by age and war, but of colors that have begun to fade. The brilliant colors that artists use today were simply not available to the Renaissance masters, or even to later masters. One of the great discoveries in recent scholarship was that, so unstable were the paints forced on the masters, Rembrandt's *Night Watch* wasn't really a night watch at all: It just turned dark and got to look that way after a century or so.

Then what chance do you have? Knowing nothing, you walk into an art store and you're supposed to guess which paints are stable and which ones aren't, or which ones will produce brilliant tones and which ones won't. Fortunately, there's an easy solution to all of this. Besides relying on the advice of your merchant—which, again, is often a pretty good idea—the National Bureau of Standards of the U.S. government has a list of approved products. Any brand on that list will have its virtues and defects, but you won't be cheated, or ruin your canvas, if you follow the list. I personally use Martin F. Webber and Bellini Oils and you can't go wrong with those two. There are, however, numerous other options that might be cheaper and just as effective.

For frames you can probably manage quite well on your own, especially if you've ever had occasion to decorate a house or an apartment. Use whatever strikes your fancy and pleases your eye. I do, however, strongly recommend that you stick to wood. Other than that just be sure the thing has four corners.

Finally, a question of national import is what toilet paper brand to use. Both candidates called me on this subject just prior to the November election, but I have no intention of endorsing any product whatsoever—not until somebody offers to pay for my testimonial . Who better than Morris Katz to do a prime-time commercial for toilet paper? I'm just waiting for an enterprising ad man to say the word.

Chapter 7

Have I Got
a
Landscape for You!

The poet John Keats wrote that truth is beauty and beauty's truth and that's all you know and all you need to know. I disagree. In this final chapter I'd like to discuss a few of the other things you need to know.

After a year of practising and perfecting your style you'll find yourself suddenly loaded down with paintings. Your garage will be filled up. Still lifes will be oozing out of the cracks in your door. The light won't be able to get in through your windows because of all the landscapes and seascapes piled up to the ceiling. Your neighbors will complain and the city council will consider rezoning your block. But you won't be able to stop. You'll keep right on turning out paintings in a creative sweat of obsessive, joyous fervor. No matter how your floors buckle from the weight, you'll paint and paint and paint some more.

When this happens to you—or even if it doesn't—there's only one thing to do. Sell what you paint!!!!

Of course this is easier said than done, so let me hand out a few tips culled from a lifetime of experience. The most important thing to remember is this: that your work, no matter how good it is, *doesn't stand alone*. Art seldom does. Music, very rarely. Literature, almost never. You have to add something to it to make it go. *You have to add yourself.*

Now I want to pause a moment over this statement, because it will offend many people. The orthodox canon is that art is transcendental, that of course it must stand alone, because every great painting or poem or sonata exhales the breath of God. To suggest that it doesn't is to contradict every value that makes us want to create these masterpieces in the first place.

But I've got news for you. Heaven helps those who help you-know-who. There never was a great painter who didn't have to politick for his art. Velasquez played up to the king, and Raphael to a count. And if the pope had not thought Michelangelo was a jolly good fellow, the Sistine Chapel could have been painted by Heime Manusch. In Van Gogh's case his brother Theo did the hustling for him.

I'll go even further and say that this is the way it *should* be. By being politic, by being a hustler and pushing what you do, you involve both yourself and your art in the great stream of humanity around you. Maybe you can find a more beautiful piece of music than Bach's *Mass in B Minor* that has somehow remained obscure. But then, by definition it is not as good, because it hasn't been important to as many people.

So wherever your art is, that's where *you* should be: pushing, pushing, in whatever way is natural to you. The buyer must have a sense of you both physically and psychologically. Pretty pictures are commonplace, but you're not. Meeting you is a big thing for him. How many artists does your average citizen meet? About one a year, I'd guess. It makes the painting special, that he actually saw you and got to shake your hand. And since it doesn't happen all that much, he can afford to spend a hundred bucks or so to commemorate the occasion.

This fascination with the person of the artist extends to sophisticated people as well. They love to paw over your psychology and will pay hard cash for offshoots of your psyche. In many cases, this is a pretty morbid and romantic business. The premium on Modigliani and Pollack is, for

example, much higher because those guys were such drunks.

Blessedly there is a more common and innocent side to this curiosity. Nice people—the kind I usually meet when I do my shows—will appreciate the fact that you are an artist. They are genuinely glad that there's someone around to do this lovely work called art, and they are naturally interested in you almost out of gratitude. Often, as I have said, people will mill around as I paint until they finally work up enough nerve to ask me friendly questions about my paintings and my life. Always answer such questions. The more involved with you, the more likely they are to buy your work. Don't *you* prefer to buy things from people you know?

Now this personal touch can have variations. In my case it's obviously my shows. The customer gets to actually see my paint and listen to me chatter about it as I do. But maybe this isn't for you. Maybe you'll never feel comfortable actually doing it in front of others. In that case, have someone throw you a party where you can set up an exhibit of your paintings. Perhaps there's a friend or relative of yours in the Tupperware business. If that's the case, you've got it made. Just tell her to invite the usual guests, but leave out the Tupperware and drag in a few still lifes instead.

When you finally figure out how to add your personal touch—whether through shows or parties or simply engaging people in conversation on the streets or at fairs—make sure to remember one thing: It doesn't do any good to be accessible to your customers if they're not going to like you. People might stand in awe of the sullen, overly sensitive artiste, but they probably won't buy anything from him. Be

as nice selling art as you would be selling real estate or automobiles.

When I do my selling I make a veritable fetish out of personability. Humor is crucial. People love to be laughing when they reach for their money. If you're a decent story-teller, have a few good ones ready. In my case, I tell stories while I paint for the audience, but if you're not going this route I suggest you tell your jokes *before* they make their decision to buy.

As for what kinds of jokes to tell, I'm the type who always finds the Borscht Belt variety goes over best, even when I'm not in the Borscht Belt. The next time you see Shecky Greene on TV, memorize his bits. I have always found that Shecky's material works well with both landscapes and still lifes.

Of course, quick one-liners are also effective, especially when they make fun of this whole money-obsessed selling process which—let's face it—engulfs us all. For example, I'll often hold up a painting and announce a price of $200.

"Lower," someone will invariably shout.

"Lower?" I ask. "All right, lower," and I'll "lower" the painting down to my knees.

In a few minutes I'll let them win and "steal" the painting from me for $100. As soon as the transaction is completed, I'll say, "When Van Gogh couldn't sell his paintings he cut off his ear, but Morris Katz keeps his ears and cuts the prices."

One of the really valuable by-products of gags like these is that they make fun of the whole mercantile life style. People feel uncomfortable with the fact that money is as important

as sex and food. They appreciate it when you display your own needs so nakedly. The dirty secret is out of the bag and people can laugh about it. It's not really so shameful after all, is it? Everybody loves money, even artists! In fact, your love of money will make them like you more. You're no longer a freak. Show them you're like everyone else in liking money. They'll no longer be threatened by this mysterious creature called an artist, who has chosen to make his living in such an unusual way. How subversive can you be when you're saving up for a house in Marblehead? By admitting to love of money and simultaneously making a joke of it, you bring the family of man back together again.

You see the ambivalence with which they view you: the fond curiosity about you, because you're an artist, and that feeling of threat, which you can easily assuage by parading your own grubby humanity. Don't ever try to pretend you're not an artist! If they want to watch somebody who looks as if he sells aluminum siding, they'll go find a man building a house. In other words, when you give a show or go to that party, be sure you *look* like what you are. Wear a beret. *I* often do; my advice is to cock it slightly to the left and pull it back a little to show a bit of scalp. Under no circumstances wear a nice suit to a show or party, but don't look poor either. If it seems you do all your shopping at Woolworth's, they'll try too hard to beat you down on your prices. Designer jeans are often helpful because they can make you look like a casual, arty nonconformist who still knows how to put a few bucks in his pocket.

Another option is to wear a nice jacket and tie with really ragged Levis. The only problem with this, as far as I can see,

is that a lot of Silicon Valley types are beginning to do it too, because it makes them feel so mellow.

My next advice is that you must never feel that the selling process in art is beneath you. Again—I'll repeat it—let's get rid of this art mystique! If you can sell insurance, Lord knows you can sell art! An insurance policy is nothing but a promise on a piece of paper, yet look at the cash a good salesman can persuade people to pour into it. A painting, on the other hand, is at least a thing. It has mass, it shows talent, it's pretty, and it decorates the most important piece of equity you can possibly have: your home! So why shouldn't you be able to sell it? Of course you can!

Once you realize how closely connected art is to selling a product, then it becomes easy. The same selling techniques apply everywhere. And not only selling techniques, but buying skills as well. Are you an office manager? Do you know how to get a good buy on paper clips? Then you can get a good buy on a painting or two as well. Even better—are you a housewife? Have you been wangling deals on meat loaf from those stolid, unyielding folks at the A&P? If so, there's no reason why you can't get a good deal on canvases as well. We're talking about profit margins and cutting overhead. Pure and simple.

My guess is, you can probably teach *me* how to sell art once you really start thinking about it!

One thing all good salesmen know is that no product is really good enough to sell without a handsome package. If you're trying to sell a painting, your chances of fetching a decent price are increased tenfold by framing it for the buyer. It's not the formidable task you think it is. In fact,

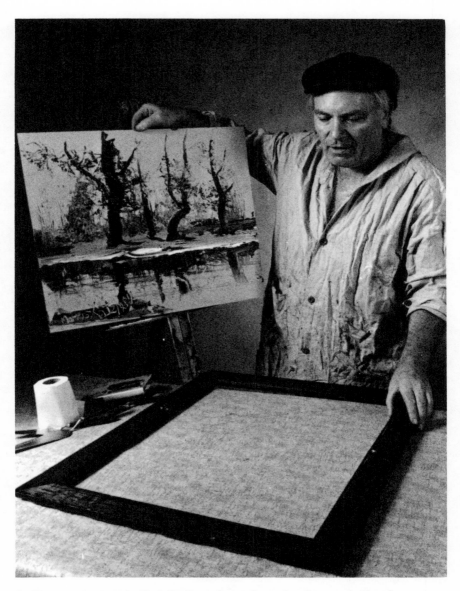

1. Your painting is finished and ready to be framed. You have a frame you think will fit.

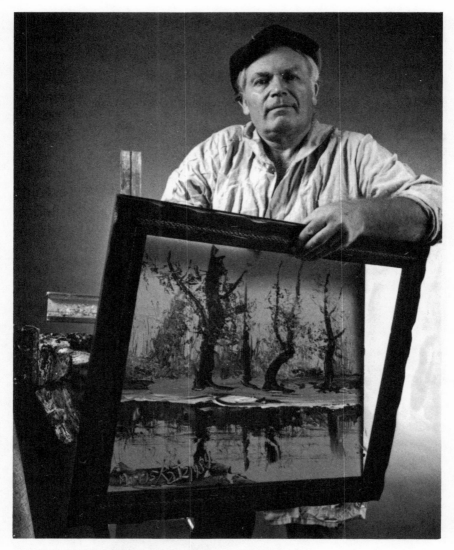

2. Check your frame for size by trial and error.

3. If it doesn't fit, the frame will need adjusting as you can't change your masterpiece.

4. Finally it fits.

5. Now you lay the frame and painting face down on your work table, and pick up your staple gun. If you prefer, you can use a small hammer and 1-inch nails.

6. Begin shooting staples into the top of the frame, or use the nails.

7. Put staples or nails into all sides of the frame. Waste a few
 staples or nails but make the painting secure in the frame.
 The whole process should take less than a minute.

8. If you are concerned about putting your oil painting face down on the table, you can hold frame and painting tightly together up in the air like this, and shoot the staples into the frame this way, as I do it on television.

This stapler, called a brad nailer, has a gun-like trigger that can shoot triangular brads such as glaziers use into the back of the picture frame. (Courtesy of S & W Framing Supplies, Inc.)

it's so simple that it would be a shame to lose even one sale just because you'd rather not bother.

Lie the frame flat on a table. Slip the canvas in on all sides. Take a staple gun and shoot four or five staples on each side, in the thin slits between wood and canvas. True, this can sometimes be a little clumsy, so buy yourself a glazier's stapler for the job. They're built for just this sort of work and will make it all the easier.

Remember, we're doing oils, and so there is no glass involved to complicate the framing. Indeed, it shouldn't be long before you're as facile at it as I am. I don't even bother laying anything down. I have the stapler in one hand, the painting in the other—and then, bing bing bing, I'm done!

There are, likewise, a thousand and one tricks that every professional picks up. It's almost second-nature the way we manufacture and use little gimmicks to beef up our sales. A retailer reduces inventory by slashing prices. It's an idea that comes automatically to all business people. Once you really know the art business, ways to sell will naturally suggest themselves in the course of a day's work.

This applies to the art business no less than to the dress business. As you become more confident, bright new sales angles will appear from nowhere. I would, however, like to give you just a few samples as a foretaste of what's possible.

One idea that has long stood me in good stead is the raffle. *You can sell a painting while giving it away.* Here's how to do it. Let's say you've just finished a landscape that you're willing to price at $50. This may not be a lot, but remember we're reducing inventory here and besides, if you've only spent ten minutes doing it, $50 isn't all that little. Figure that at the least you've made $45 after subtracting the cost of supplies. If you could make $45 every ten minutes, for a forty-hour week you'd be earning $10,800 that week, which is a yearly salary of well over a half-million dollars—no mere bag of shells, not in my country!

Tell your audience that if there are fifty people in the room willing to stake just $1 apiece, someone will win a beautiful painting. If there are, ask each of them to put their initials and room numbers (assuming this is a hotel show) on the dollar bills. Have a trusted friend collect and hold the money for you. Do not pick up the bills yourself because, as everyone knows, it's unseemly for a great artist to wander around grabbing up money like that. In fact, use assistants

for all your financial transactions wherever possible. Not only will this make you look like a real entrepreneur, but it will free your time and energy for more art. And the more art, the more money. An assistant will pay for himself in no time.

If there's no trusted friend to collect the bills, simply ask for a volunteer. People love to help. It gives them a greater sense of being involved. Remember, this isn't an auction at Sotheby's. First and foremost, your audience is there to have fun, and asking them to participate so directly can only enhance their fun. Don't worry about the volunteers with the money. They won't run away.

Once you've got all the dollar bills together, you have to pick out the winner. Give a good show when you do. Put the bills in a basket. Shuffle them up. Pick up a bill and rub it against your forehead. Beseech the heavens for guidance in selecting the most deserving person. Chant an incantation or two while you finger the bills. And don't forget to make a big fuss when you pick the winner and hand over the prize.

Now what have you achieved? First of all, you've sold your art. In a three-hour show, I like to sell at least four paintings in this way. Second, you've made someone very, very happy. Imagine what this will add to his vacation! And finally, you've hurt nobody. The losers are only out of a dollar each and they've gotten a good laugh for their time and money.

Something else I've learned is that once a person agrees to buy one painting, the chances are that he'll be willing to go for a second. This is especially true if he thinks that the second investment will somehow complement or reinforce

the first. There are many ways to honestly exploit this tendency to your own advantage, but for me the most frequent comes when the customers ask for advice on protecting the painting. I paint wet-on-wet, and if the painting is still not dry when it's sold, the buyer is going to wonder how to get it home without messing it up. Even if they're only taking it upstairs to their hotel room, they'll often be most concerned about guaranteeing its condition.

What I do is to simply advise them to buy a second painting of exactly the same size. That way we can fit the frames together, face to face, and by tying a cord around the back the paintings will protect each other! You'd be surprised how often people jump at the idea! You see, deep in their hearts they want to buy a second painting anyway, but they'd feel extravagant doing so. By giving them a sound, pragmatic justification, I eliminate their guilt while improving their vacation with yet another special little treat. In the meantime, I make more money for myself, and everybody goes home happy!

Psychology is everything. Learn to look at what you're selling as if you were the customer. What do people value in art? Aside from quality, they value, as I have said, the personality of the artist. Now everyone knows that an artist's work is worth more after he's dead. Death gives him a certain authority, as if he has now gone to live where Rembrandt and Leonardo live, wherever that may be. Even in the narrowest practical sense, death increases value because the artist won't be doing any more work. His creative output is no longer open-ended and, in a few years, the artwork of even so prolific a painter as Morris Katz will be

scarcer. At the very least it is undeniable that any major decrease in supply will proportionately increase demand. Therefore, always emphasize that you're not immortal!

So there you have it: Instant Art, the greatest thing since cornflakes. I have in these few pages gone out of my way to mix up the sacred and profane in a way that I feel truthfully mirrors not just the life of the artist but everyone else's as well. I think each of us should try to learn to accept both the sublime and the ridiculous as gifts from a great God who is not altogether lacking a sense of humor.

There are many other books I ought to write, and I hope you'll encourage me to do so. First of all, there are a number of technical issues I'd still like to address: mixing colors, doing seascapes, trying out acrylics, and experimenting with a host of special effects that we haven't even begun to touch on here.

Earlier I mentioned how, during the years I was developing Instant Art, I was also honing my skill as a portrait artist. The question arises, can you possibly do a portrait in Instant Art, and still bypass the training required to achieve verisimilitude?

Yes, one can certainly do some striking portraits using procedures similar to the ones outlined in this book. There are, however, so many variations and complications that I really must defer discussion of the technique to my next book. I would also add that, for truly striking portraits, the kind that capture the depths of a person's soul, there's no real substitute for conventional training. Instant Art can produce effective likenesses, but the best portrait painters should at least begin their studies with the brush.

Finally, there are numerous stories like Saul Blitzstein's that I'd like to chronicle. What more significant addendum to Instant Art than the actual experiences of the numerous men and women who have tried it? After all, isn't that the essential difference between what I do and what the academicians teach? Where they concern themselves with the aesthetic preoccupations of the elite, I concern myself with the pleasures of all people. Once we open the flood gates of a truly democratic art, there's just no limit to the range of tales that will cry out to be told.

Index